LAYERS

FELTED ART PROJECTS SPARKED FROM THE SOUL

KRISTEN WALSH

Layers
Felted Art Projects Sparked from the Soul
Copyright © 2020 Kristen Walsh
All rights reserved.

No part of this book may be reproduced in any manner whatsoever without the prior written permission of the publisher, except in the case of brief quotations embodied in reviews.

ISBN: 978-1-61244-908-1
LCCN: 2020919904

Halo Publishing International, LLC
8000 W Interstate 10, Suite 600
San Antonio, Texas 78230
www.halopublishing.com

Printed and bound in the United States

This book is dedicated to two of the people who helped me on my path to healing, believed in me, enabled me to grow more fully into my "skin," and loved me no matter what.

Patrick,
my number one cheerleader and the love of my life.

Linda,
who walked this sacred path of healing with me
and breathed life into this artist.

Contents

Chapter 1	7
Layers	
Chapter 2	11
General Felting Tips	
Chapter 3	19
Needle Felted Landscape Project	
Chapter 4	28
Double-Layered Needle Felted Landscape*	
Chapter 5	36
Hard Days	
Chapter 6	38
Layered Beads	
Chapter 7	61
Retreat	
Chapter 8	63
Mandala	
Chapter 9	78
Ritual	
Chapter 10	80
Sacred Light Lantern Project	
Chapter 11	98
Healing	
Chapter 12	101
Tiny Book Project	

Layers

Chapter 1

Take a moment to think about layers. They are everywhere. For example, consider Earth's atmosphere—troposphere, stratosphere, and mesosphere (yes, I looked that up!)—and the surface of the earth—crust, lithosphere, mantle, and inner and outer core. How about layered cakes (yum!), our skin, layers of clothing, lasagna and burritos, paint, and baklava? I bet a few more ideas also come to your mind.

Our lives can be layered, as well. We do the same things year after year, but as we grow and change, it isn't the same thing, is it? Each experience "informs" the next one; **what we learn one day helps us learn and understand something the next day**.

Right now, I sit by the ocean, looking at a beautiful sunset. The sun is slipping behind a layer of clouds. I think about the sea life teeming beneath the top layer of the ocean, layer after layer of it. Some sea life stays closer to the top layer, and new life is still being discovered in the deepest layers and depths.

Layers and Life

Aren't our lives, if we choose to really examine them, layered just like all of these things? I like to think about how an onion consists of layer after layer and then imagine my life's path in a similar way. As I peel away each layer, I get closer to the core: my authentic self. I imagine pushing something into that onion, like a bamboo skewer. The hole on the outermost layer is easily seen, but as layers are peeled away, that hole, though it gets smaller and smaller, is STILL there. To me, that hole is a metaphor for our wounds. We may heal from our wounds, but the scar is still present.

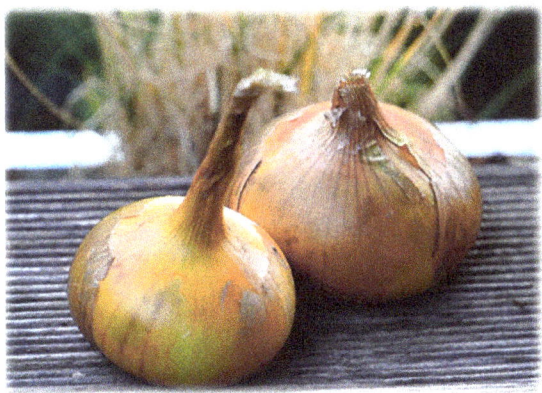

We all have wounds from various life events, people, and situations. Life is messy. Some of the wounds create deep scars that stay with us all our lives. By peeling back the layers and examining my life and the things that formed and wounded me, I've found that the scars, though still present, get smaller, just like that hole in the onion.

I cannot get away from the idea of layers. I am an artist working in felt, which means I layer wool in order to create art. One of the techniques I've developed and now teach is using layers to make landscapes and seascapes. These multilayered works of art use small peepholes so you can see the layers below. You'll learn the process in this book.

As a teacher of art, I've seen firsthand how the process of making art allows for deep inner work and can begin healing our wounds. I've seen people leave my classes astonished at what they created, perhaps not having the self-confidence to believe they really could create. I've heard my students get into deep conversations about intimate things in their lives because they were side by side with another person while creating. I've also heard students make "dates" to see each other after a class in order to continue their conversation. "Making art" is so much more than the actual process of making art!

Why Do We Create?

I have yet to meet a person who isn't creative. One of my pet peeves is that we define "creatives," "makers," and especially "artists" WAY too narrowly. Are visual and performing arts the only ways to be creative? Of course not! Most would agree, yet we still uplift people who have been deemed "artists" as the only "real artists."

What about the rest of us? We fail to see the creativity in everyday things, such as how we run a business or our homes.

There's a woman at my church who would absolutely deny that she is an artist, but what she can do with a challenging church budget…WOW! That job takes creativity and artistry. My husband runs his own business. Dealing with difficult clients, challenging employees, budgets, and the like takes creativity. Would either of these people say they are creative or artistic? Maybe not, but I do!

But back to my original question: Why do we create?

Some may disagree with me, but I believe we create because we are made by the Creator in His image. So, we're little creators! We can't help it. In fact, we "groove" on creating. It's the skin that we wear most comfortably.

Even if you have different ideas of where our desire to create comes from, I'm sure you can agree with the idea that we all have artistry and creativity inside of us. Wouldn't it be great if we could embrace it more readily?

My Beginnings with Art

Without going too deeply into my life story, I do want to tell you that I didn't always think of myself as an artist. My grandmother and my mother were oil painters. THEY were artists. When I decided to enter into therapy to deal with some of the mess of my childhood—primarily neglect due to an alcoholic parent—I showed my therapist some projects I was working on. She immediately said, "You're an artist!" I can still feel the panic I experienced when she said those words. I've tried to unpack them over the years. The best I can come up with is this:

1) Though I sat side by side with my mother and did artistic things, I didn't feel encouraged in my creative endeavors.

2) My mother and grandmother fit the definition of "fine artists." Somehow, they were the "real artists," not me. I mean, they put their art in frames!

3) The title "artist" seemed loaded with expectations. People could judge my work and judge *me* by my work. I could be criticized. I simply wasn't interested in dealing with all of that.

My definition was so narrow. As a teacher of art, I have seen firsthand how creative we all are. Some may take their art to the next level by making it their career. Some find critical success, and some do not, but ALL are creative. If there is a way I can encourage others to embrace their creativity and artistry, I want to do that. Perhaps this book is a step in that direction.

Once we've embraced the idea that we are creative and artistic, the power of art can really be unleashed. I believe that in doing something creative, we open ourselves up to *more*—more emotion, more understanding, more empathy, and more of everything. This is one reason why art is so great for working out our issues and wounds, as we are more open when we're doing it.

When I began my therapy journey, I journaled like crazy. Along with pages of writing, I have pages of scribbles and red paint from times when I was too angry for words. There are pictures and poems. There are pages of collected quotes that had special meaning. I created a sculpture of a woman on her knees, head and arms thrown back in anguish. Under her gown is a ripped place where her heart is. I couldn't verbally express my pain,

but I could sure see and express it in my sculpture. To me, the mystery is how our pain can be minimized, dealt with, and even vanquished when we express it.

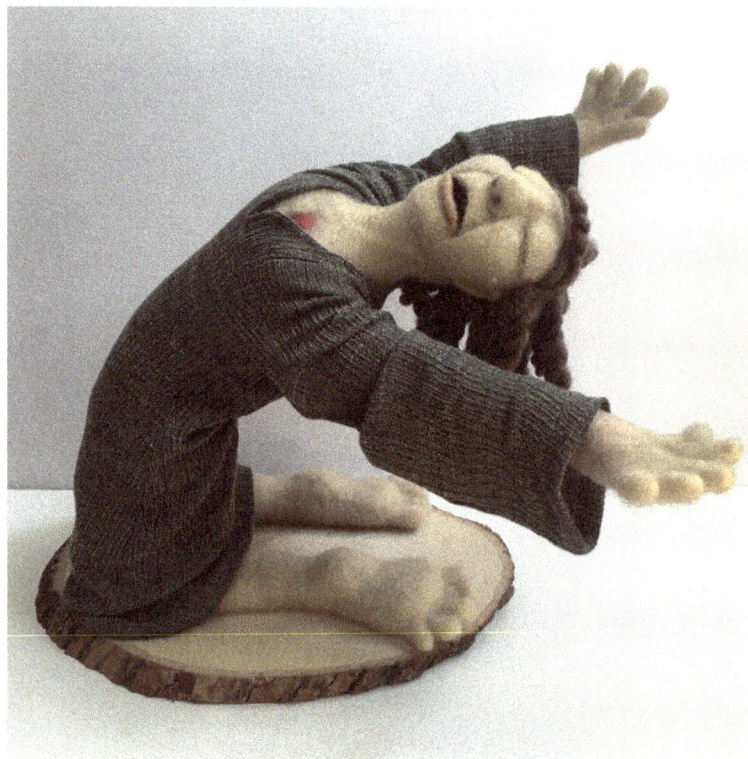

Art as Therapy

I was fortunate to have a very "art friendly" therapist. One day she suggested I write my story. The idea was NOT appealing to me initially, until she suggested doing it in a fairy tale style. That lit me up. I worked on my fairy tale feverishly and then started working on illustrating it with felted scenes. I poured myself into it.

Somehow, writing my fairy tale helped me get my arms around the whole "story." I could wrap my brain around it. It helped me see the mess in its totality. I could see that my story wasn't the worst, but I could also see that it wasn't wonderful, either. The main thing is that I could "see" it—not just think about a small part of it, but "see" the entire mess, even if it was in very broad strokes. I believe that seeing our wounds for what they are, and not simply reacting because of them, is crucial for any healing to occur.

All of the projects in this book have the element of layers in them. Some ask you to delve more deeply into your inner self than others. My hope is that you'll make the projects personal. Use this artistic time to unpack what makes you tick, and allow the art to begin healing any wounds you have.

General Felting Notes

Chapter 2

If you've never done any felting before, this section is for you! We'll work through some of the basics of felting, including how to use the needle and so on. DO NOT BE WORRIED. Felting is very user-friendly. You can do this!

If you're an experienced felter, move past the next section and go to the first project.

Why Does Wool Felt? And What is Felt, Anyway?

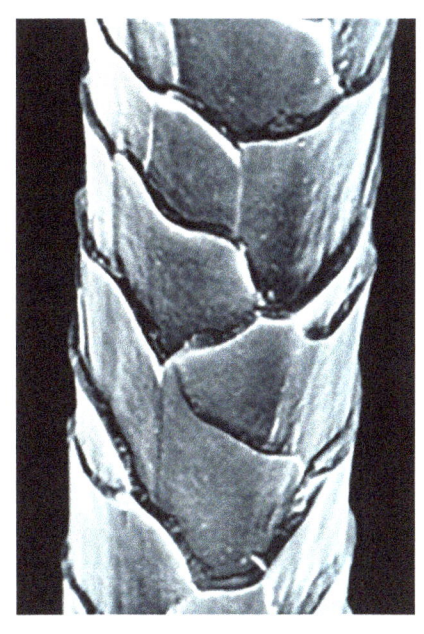

The photo on the right depicts a microscopic view of a single wool fiber (photo credit CSIRO ScienceImage). When these fibers are rubbed against each other, the scales, along the fibers, catch on to the neighboring fibers to form a tight, non-woven (meaning it is not formed on a loom) "fabric." This characteristic is what allows us to make beautiful two- and three-dimensional art from this amazing fiber.

How Do We Rub the Fibers Against Each Other?

1

We move the fibers against each other using a felting needle (as described below) or by using wet felting techniques, which involves using warm/hot water, soap, and our hands to agitate the wool fibers. I'll show this a little later in this section. You will learn more about each technique in the projects section of this book.

Organizing Wool Fibers by Carding

The length of a wool fiber is called its "staple length," and it can vary greatly. When you purchase wool, it is often in a "bat form," with the fibers going every which way. You can

11

felt with the wool just as it is, but you'll find that you will have a nicer product if you take a few minutes to "organize" your fiber. "Carding" is the process that accomplishes this.

When wool is carded, the fibers are aligned so that they are more parallel to each other, which makes a smoother, finished surface. For a large quantity of wool, you'd use wooden carders (pictured below). As we will be using only small amounts of wool, we'll card our wool using our fingers instead.

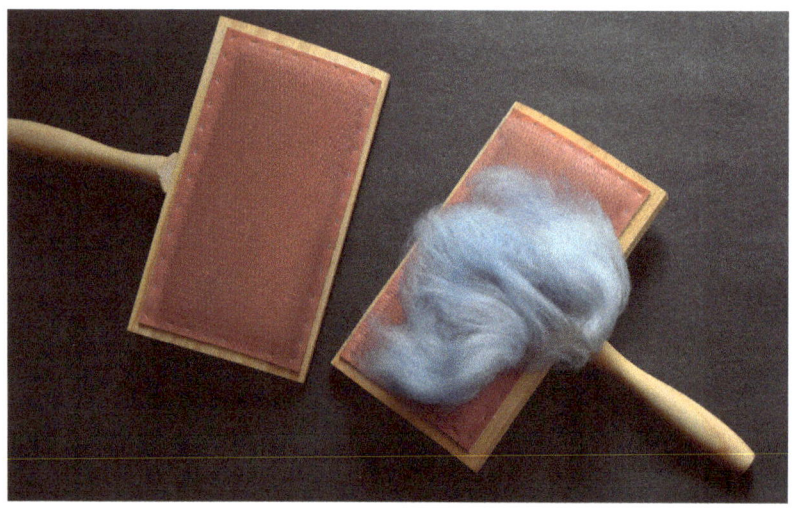

2
wool carders

By gently pulling on a small piece of wool with your fingers (3) and allowing the fibers to slip through until you have two pieces (4), you are carding the wool. Then carefully stack the two pieces of wool one on top of another (5 & 6) and repeat the process a few more times. Since you are using your fingers to organize the wool fibers instead of using wooden hand carders, this is called (surprise!) "finger carding."

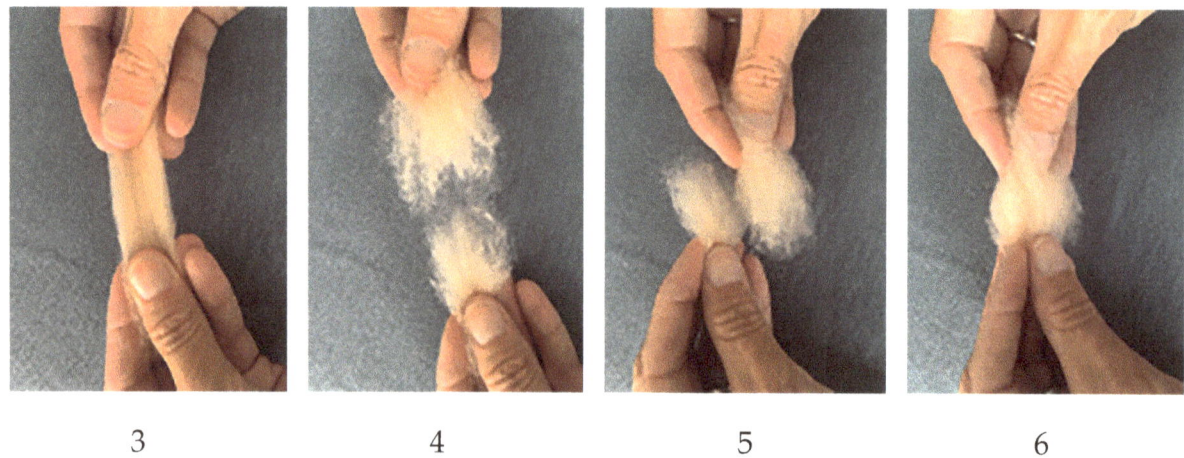

3 4 5 6

Needle Felting

Care of Needles

Needle felting needles are *very brittle* and will break if dragged in a sideways manner. I cannot stress this enough! Make sure you needle your work in an up-and-down fashion (7). Do not try to move the needle sideways to drag wool into place. This is especially true when the needle is inserted into your work or foam pad (8).

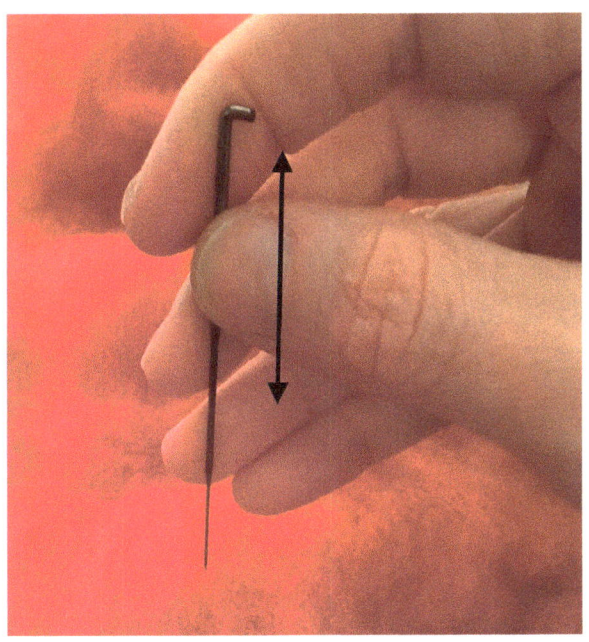

7

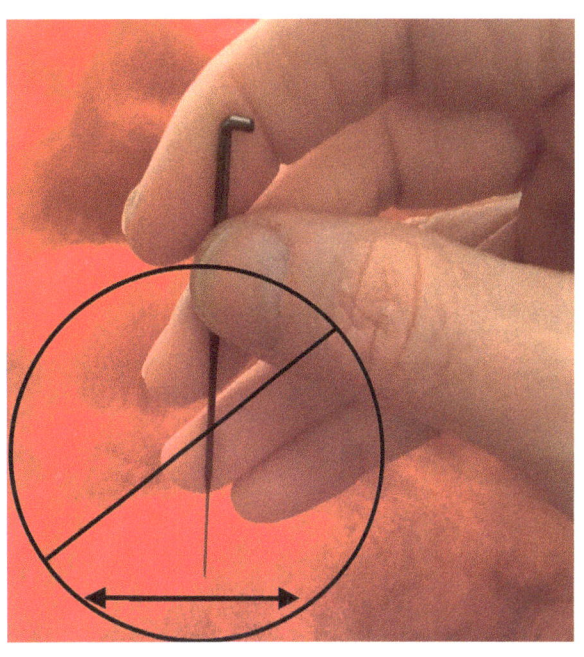

8

Work Surface

When you use a felting needle to felt wool, you also need to use a soft pad as a work surface. I use high-density foam bought in a fabric store. (The foam I buy is typically green.) Regular foam (usually white) that is not "high-density" will not last very long.

The foam is important. When you work on a project, you want to work DOWN into the foam. It *prevents the needle tips* from breaking and *protects your fingers* from these very sharp needles!

Anatomy of a Felting Needle

Look at the picture of the felting needle below (9) and then look at the picture of the tip of the needle (10). Examine *your* needle. Do you see the barbs at the lower part of the needle?

This is the working part of the needle. Anything above that section does not do any of the work of felting. I tell you this because if you poke your needle into the wool and foam and push it higher than those barbs, YOU ARE WASTING YOUR TIME AND ENERGY! In photo 7 (earlier in this text), you can see that I place a finger just above those barbs to act as a "collar" that stops me from pushing the needle in farther than is necessary. Efficiency is important. You'll be doing a lot of poking.

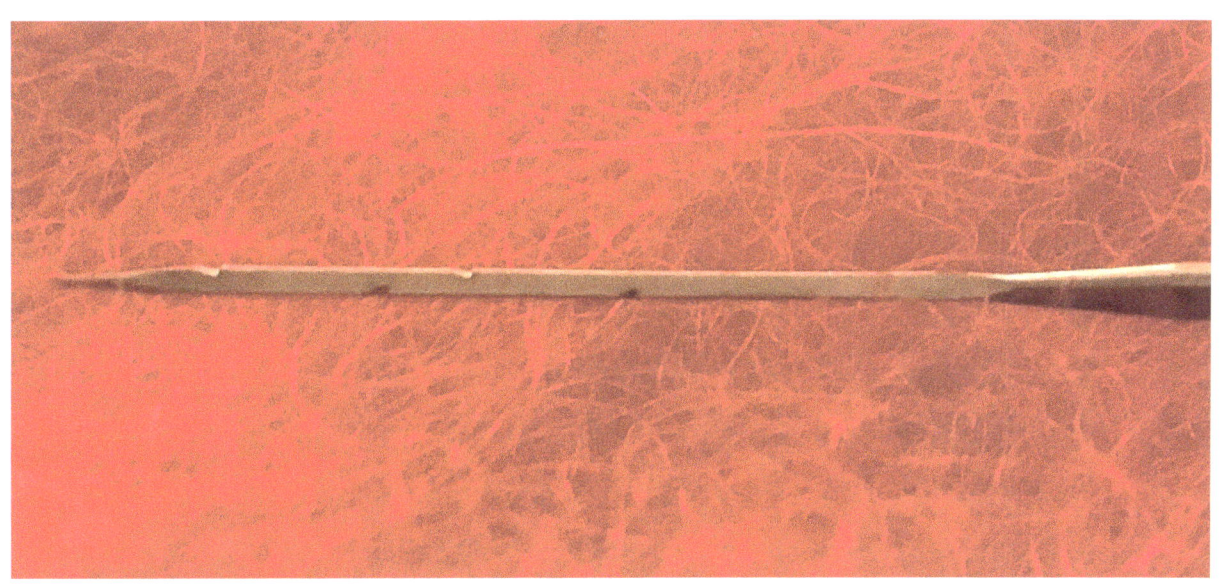

9

10

Wet Felting

In wet felting, just like the dry version (needle felting), we need a way to rub the wool fibers against each other so they "catch" and join together. Warm water, soap, and your hands are all you need to begin the process. The warm water helps open the scales on the wool fibers. The soap allows the fibers to slip against each other, and your hands are moving the fibers.

Water: As stated in the last paragraph, your water should be warm, but I have found that cool water works, as well. It just makes the process go a little more slowly. I have felted balls in a lake, and it worked! When working on two-dimensional projects, it's important to wet your project carefully so you don't disturb the design. This is covered in more detail in the individual project instructions.

Soap: There is a lot of talk about needing special soaps to felt. Many people swear by olive oil soap. In my experience, ANY soap works. The main difference is how your hands will feel afterward. The olive oil soap makes your hands feel soft and moisturized.

Hands: Whatever project you are doing, when wet felting, you have to start very gently. I usually tell students to barely vibrate their hands on their project when starting. It's hard to believe that anything is happening, but it is. Too much pressure and movement can destroy your design and make holes in your work.

Wet Felting vs. Needle Felting

Why do one method over the other? There are pros and cons to both methods.

Wet Felting: If I'm wet felting a landscape, the movement of the fibers creates lovely swirling skies and beautiful churning seas because of the soap and water. But if I'm trying to make something with a lot of dimension, or even a three-dimensional sculpture, using the wet felting method won't be effective. In wet felting, we are rubbing and pressing down on our work, which flattens the wool.

Another downside to wet felting is that it is limited to locations where there is water (and preferably warm water).

Needle Felting: Needle felting or dry felting uses the barbed needle described earlier. It's a wonderful process for creating sculptural works and for adding very small detail to any felting project.

On the positive side, one of the things I love best about needle felting is that it is so portable. I rarely go anywhere without a small project to work on in my spare time.

Visual Comparison

Below are two landscapes. The first is needle felted. It has lots of texture, especially on the tree trunk and flowers. The clouds in the sky, however, are rather flat in appearance. The second landscape is wet felted and has a lovely sky, but texturally, it is flat.

Ultimately, it's best to be comfortable with both methods so you can combine the techniques into your art.

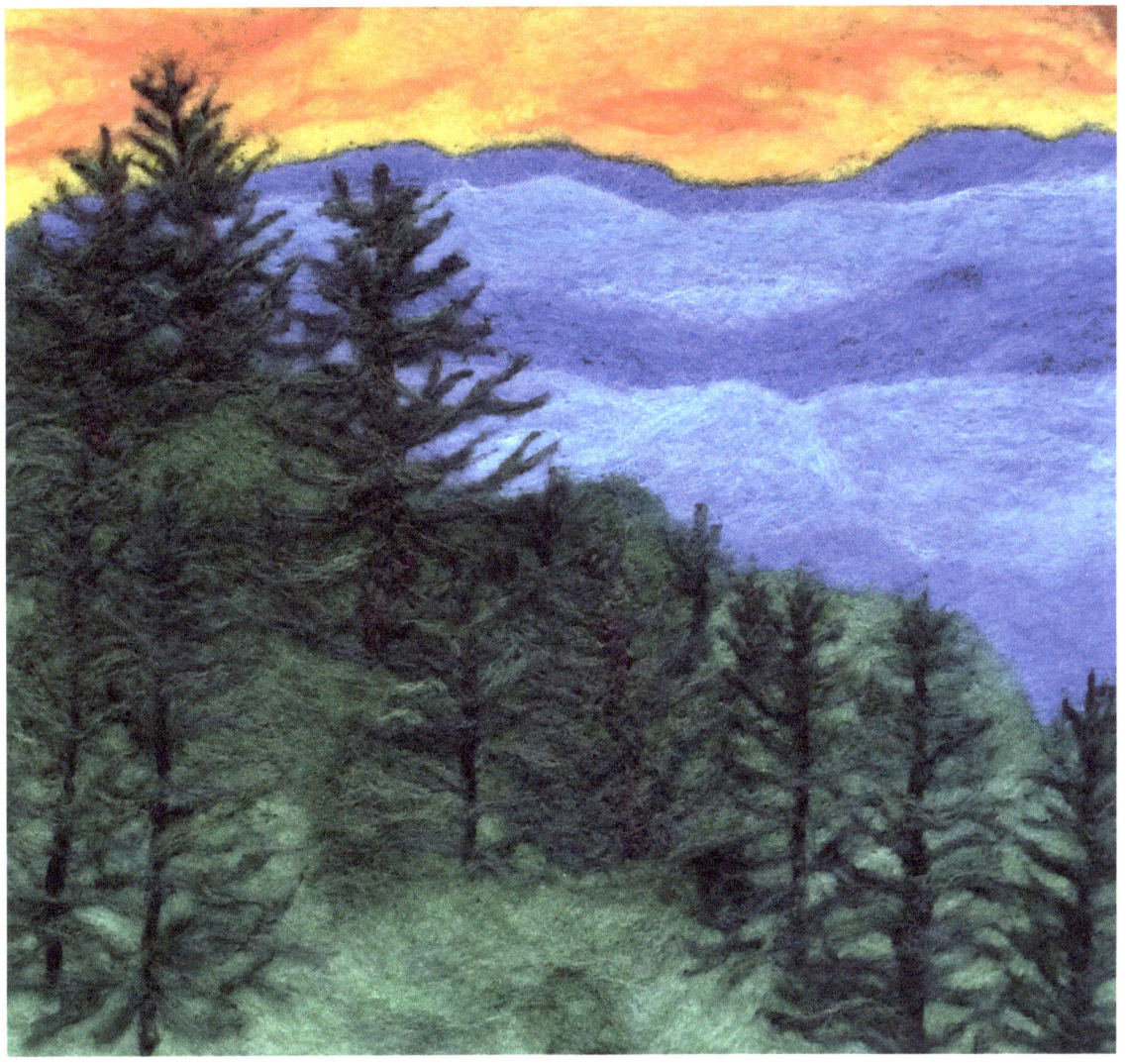

needle felted landscape

(great for adding texture, as shown in the tree trunk, rocks, and flowers)

wet felted landscape

(the soap and water help create beautiful swirling skies and water)

Image Cited

[1] CSIRO ScienceImage, "Electron micrograph of a clean merino wool fibre", 8 September 2000, scienceimage.csiro.au/image/2487. Web. 1 June 2020.

Take a moment:

These first two projects are great for making a scene that is special to you. This may be a real scene or an imagined one. My hope is that you'll feel you can enter into it. Maybe it is a safe place to escape difficult circumstances. Maybe it's a favorite spot from your childhood or a place where you've dreamed of going. Or maybe it's a place you've simply imagined. I'm going to walk you through the <u>general</u> steps to make a needle felted landscape. Use these directions as a guide to make <u>your</u> scene unique and personal to you.

Needle Felted Landscape

chapter 3

What you need:

- 100% wool felt (size is your choice, but I find 8x10 or larger easier than something tiny)
- wool roving or bat
- (colors: white, tan, several greens, light and dark grey, several browns, several blues)
- needle felting needle
- foam pad

Step 1: Background Layer

Lay your piece of wool felt on your felting pad and begin adding your colors in the order shown below (1-3). Needle them LIGHTLY! No need to needle them firmly just yet. Think about placement at this point, removing and redoing as needed.

1

white & tan

2

light & darker green

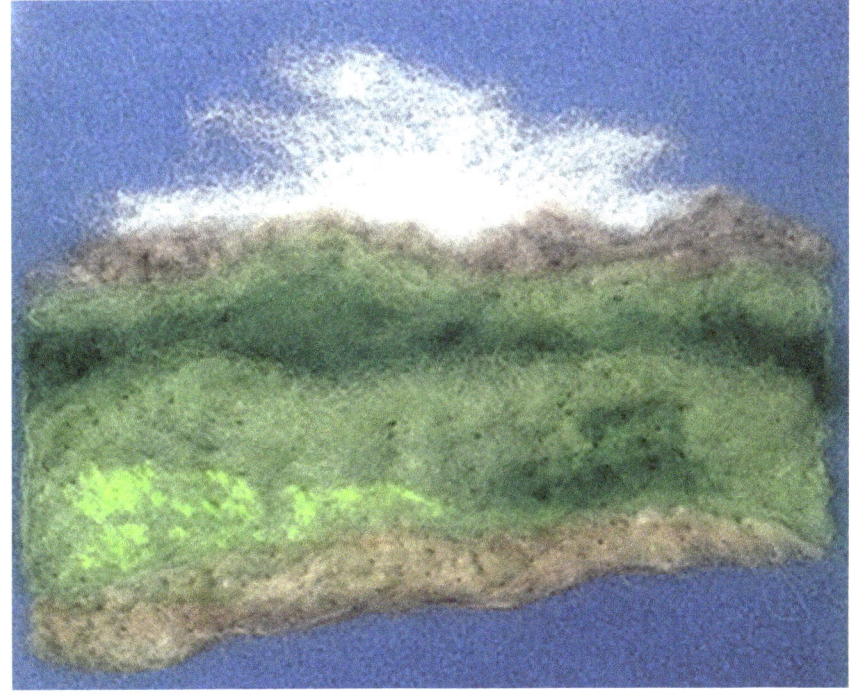

3

light green, bright green, & tan

Step 2: Rocks

Lay a small piece of light gray fiber on your felting pad and lay just a few fibers of dark gray wool across the light gray wool (4). This will be the "veins" of the rock. Turn this piece over.

4

Roll this piece of wool into a small ball, leaving the dark fibers on the OUTSIDE of the ball (5). Gently and carefully needle these balls only enough so that they hold their shape (6). Sometimes it's helpful to hold the ball in place with another needle to spare your fingers a nasty stab (you don't want a red rock, do you?). Make seven or eight rocks in total and set them aside.

5 6

Step 3: Tree Trunk Base

Lay the darkest brown wool vertically on your landscape (7) where you want your tree to be located. I usually felt starting at the bottom for an inch or two (depending on the proportions of your landscape) and then separate the wool into three or four individual branches as I reach the top. **Again, it isn't necessary to needle the trunk down firmly or hard. This will happen later, once you are totally happy with the placement of the elements in your work.**

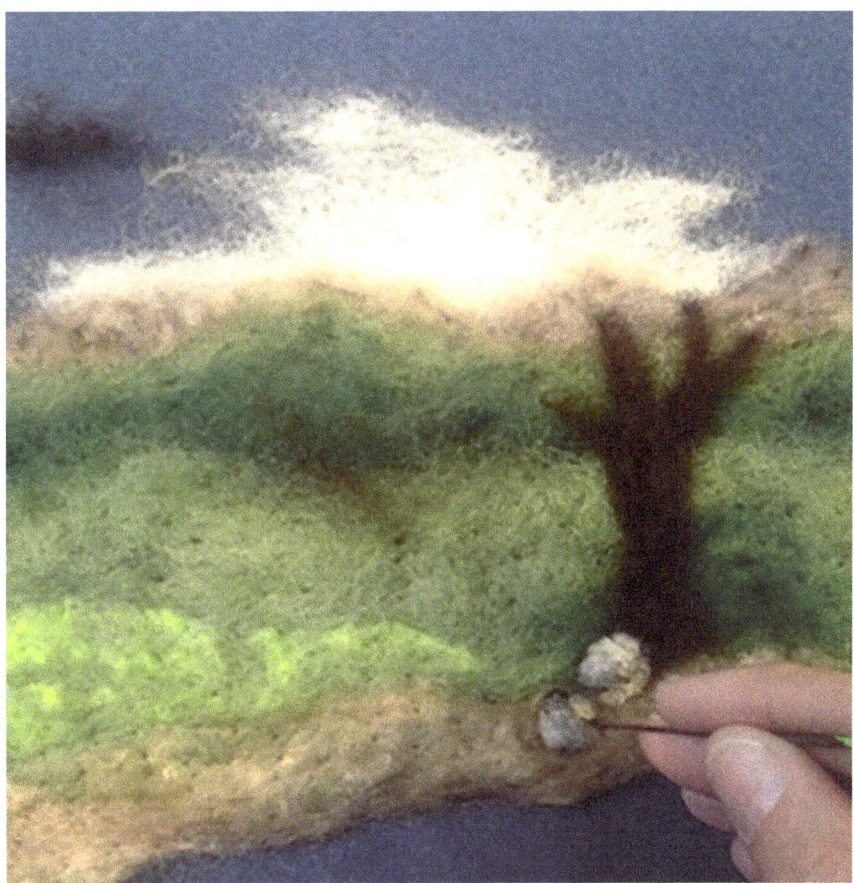

7

Step 4: Adding the rocks

Now it's time to add the rocks to your piece by needling around the perimeter of each rock (also shown in photo 7). Never needle over the top. It will flatten it too much. Needle all the way around until it is firmly attached to the work.

Step 5: Tree Trunk Texture

Adding lots of texture to your tree trunk will draw the eye of the viewer into your scene. Use a thin piece of wool that is lighter than the wool you used for the initial base

of your tree, attach one end to the root area of the tree, and then gently twist the wool, forming a "string" (8). If you twist a lot, the "string" will begin to loop on itself, a look that might be exactly what you want. This is how I make a tree especially gnarly. I often temporarily tack down a "string" and start another, which I can then twist with the first one (9). At the very least, make sure your "strings" cross over each other. Having them run straight up and down the trunk will not look authentic.

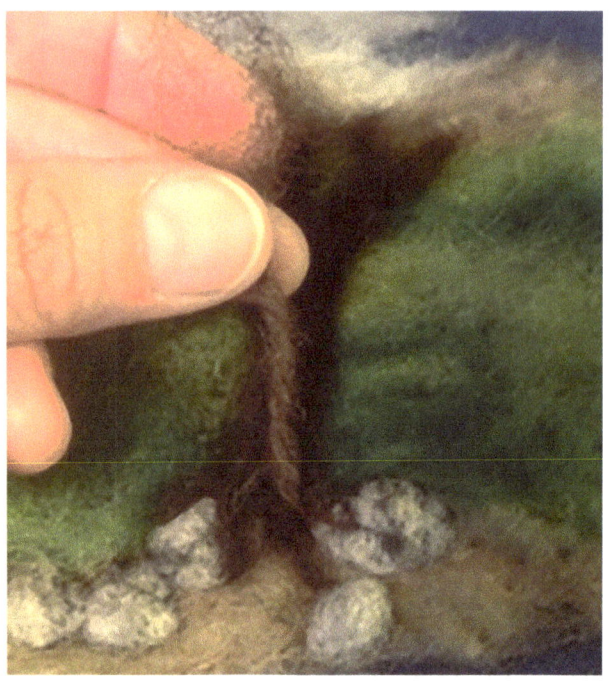

8

forming a "string" for texture

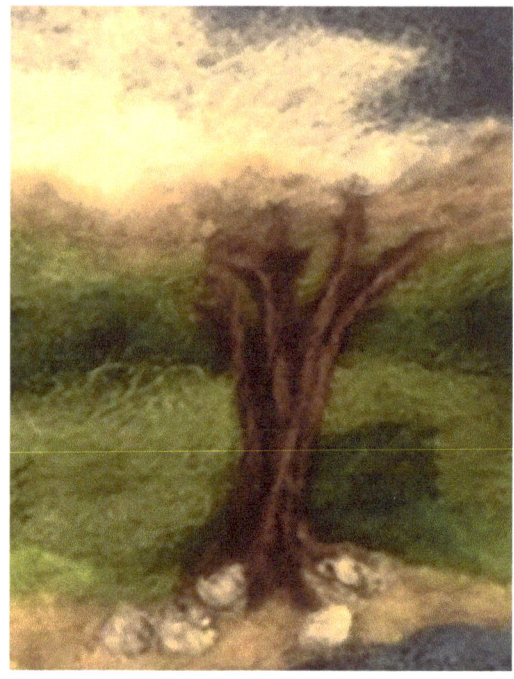

9

make the "strings" cross & intertwine

Step 6: Water

For my landscape, I have a stream in the foreground. Take a look at the progression of photos below to see how I added dark "lowlights" (10) and then white "highlights" (11).

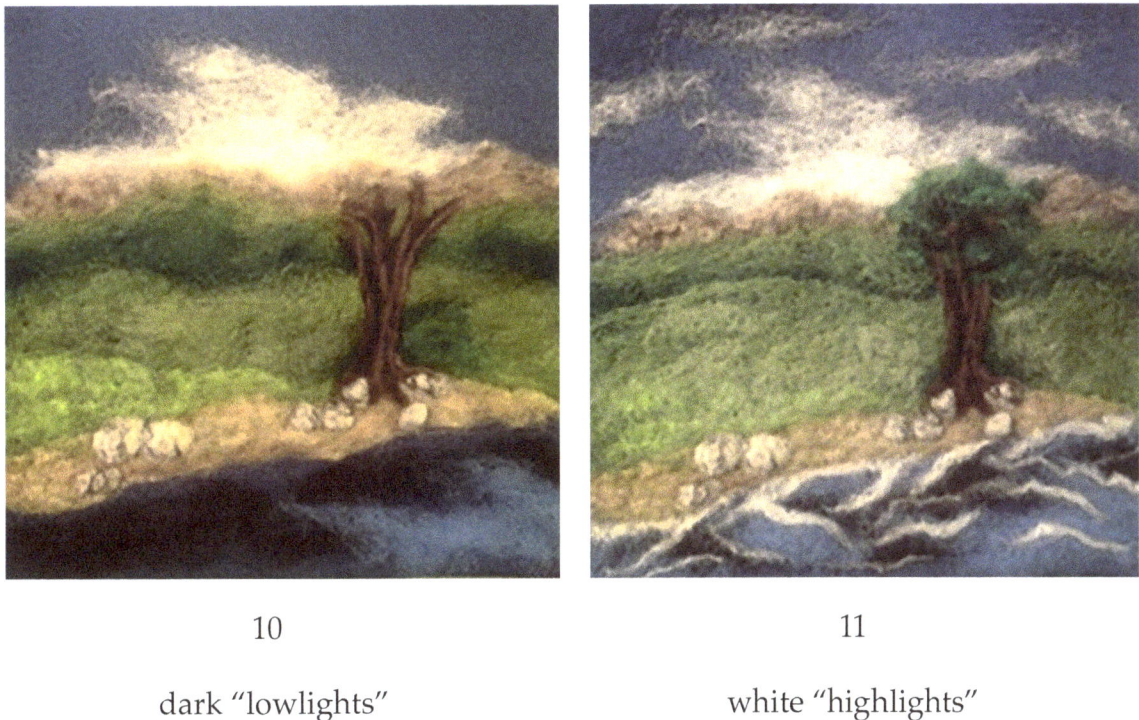

10	11
dark "lowlights"	white "highlights"

Step 7: Last Things

You'll notice in photo 11 that I added some of the green foliage to the tree. There isn't a special technique for this. Just work with several green hues and use small amounts at a time so you don't end up with a tree that looks like a lollipop! Also, don't cover all of the branches with the foliage. Make the foliage "spotty" so that the branches and the sky show through the foliage.

Now compare photo 11 with the next photo. You'll see that I did several things:

1) I added more foliage to the tree, making it thicker in some parts and thinner in others for texture.

2) I fine-tuned the white highlights in the water by moving them around and thinning them out. A large blob of white just doesn't look realistic.

3) In the same manner as the tree trunk texture, I added grasses at the base of my tree. I tried to make mine sway, as if the wind were gently blowing them.

You may wish to:

1) Add more clouds. Add a few, barely tacking them down. Stand away from your piece and determine if you like them or not. See the beauty of needle felting? Don't like them, remove them!

2) Now take time to needle the entire surface. You can purchase needle holders that hold from one to 20 needles. My favorites hold two needles and six needles. They are perfect for this purpose, BUT make sure you don't flatten out your tree trunk or rocks!

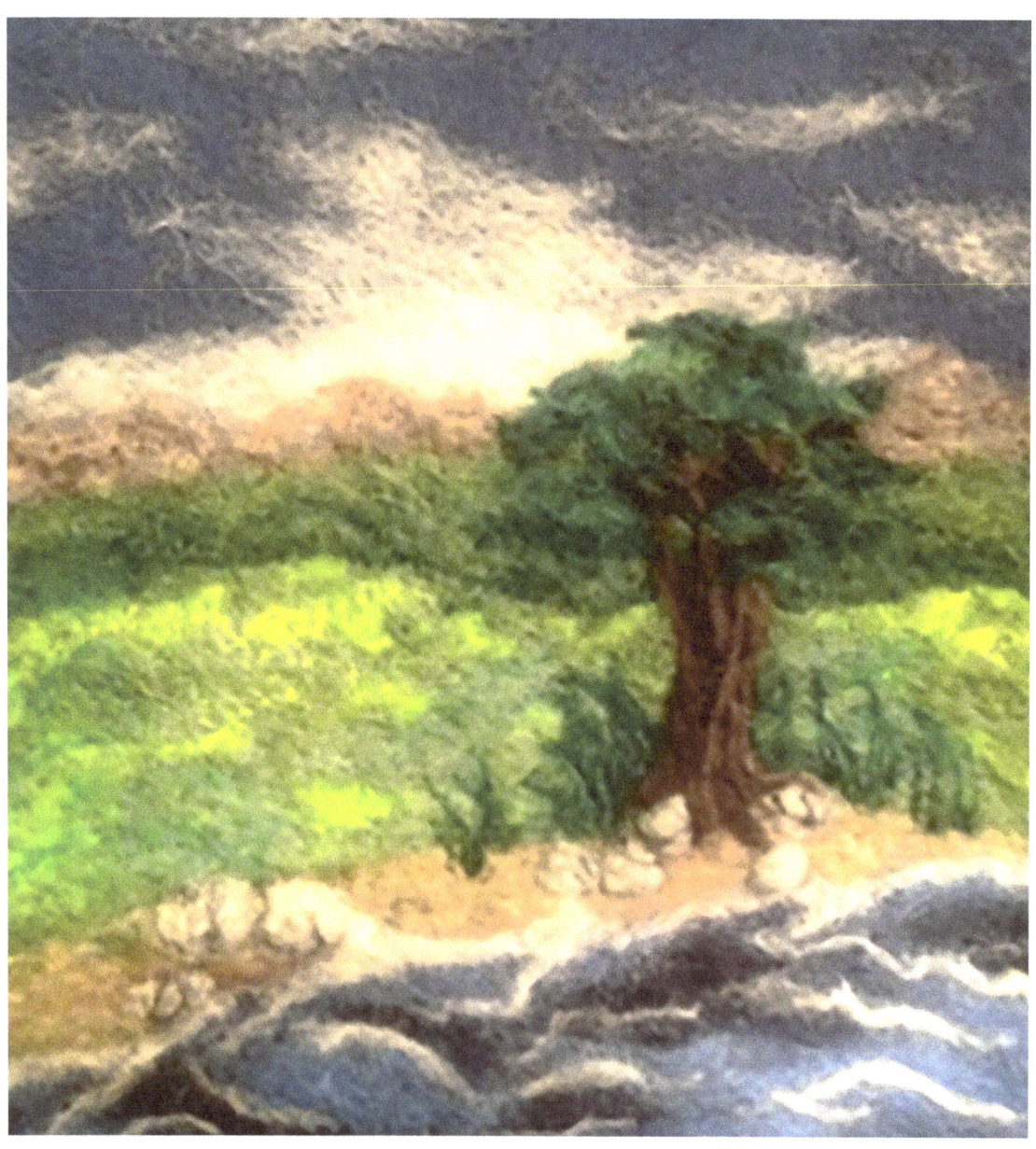

TA-DA!

Another example:

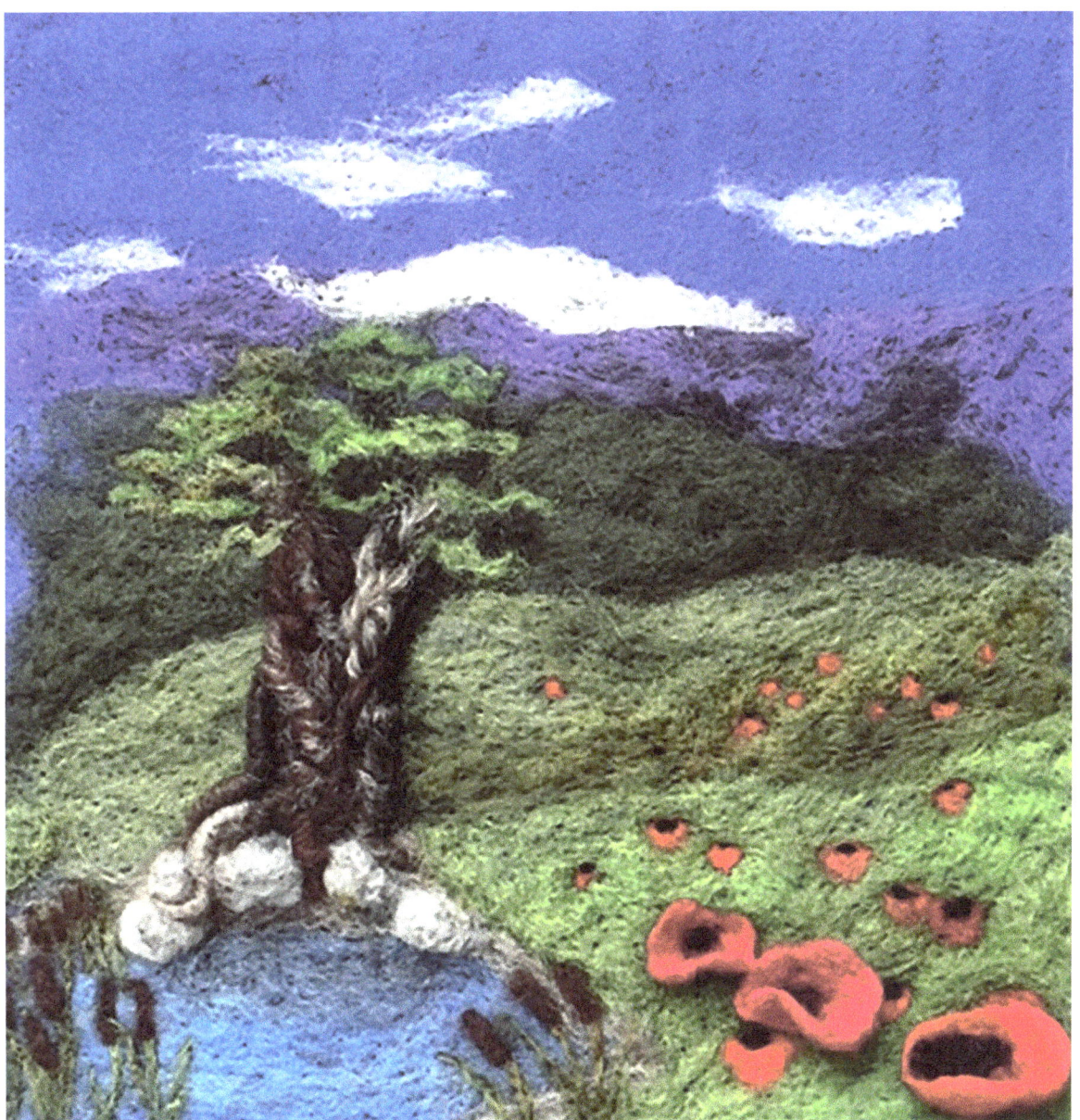

Take a moment:

If the first layer of this project (the previous project) ended up being more technical in order to master the techniques, perhaps this second layer is the time for you to really focus on the scene. You may want to include a plant or flower that is special to you, or a bird in a tree (birds and feathers have all sorts of deeper meanings). Make your landscape special to you.

Double-Layered Needle Felted Landscape*

* This project builds on the previous landscape project, so do it first. It doesn't require any different materials, just the same wool, the same needles, and one more piece of wool felt that is the same size as your first piece. Use the second piece of wool felt and continue with these directions.

What you need:

- the finished single-layer landscape from the previous chapter
- 1 piece of 100% wool felt, the same size as the previous project
- wool roving: white, tan, several greens, light and dark grey, several browns, and several blues
- needle felting needles
- foam pad

Now, for more fun, we'll add a second layer to your single-layer landscape to give even greater dimension.

Step 1: Plan your scene

Lay your finished single-layer landscape from the previous chapter and a second piece of wool felt (fabric)—that has the same dimensions as the first—on your felting pad so that they are lined up (1) one above the other. This will help you gauge the placement of the trees on the new, top layer. The first landscape you created will be the layer in the back of your layered artwork. Since the new piece of wool will eventually be on top, you'll want the trees and other features on the new piece to be slightly larger than your last landscape, as they need to feel closer to the viewer (2). You also want your new trees (or other elements) to be placed carefully so that the "old" tree shows. I do like them to overlap a bit, though. Using a ruler or yardstick will help with this.

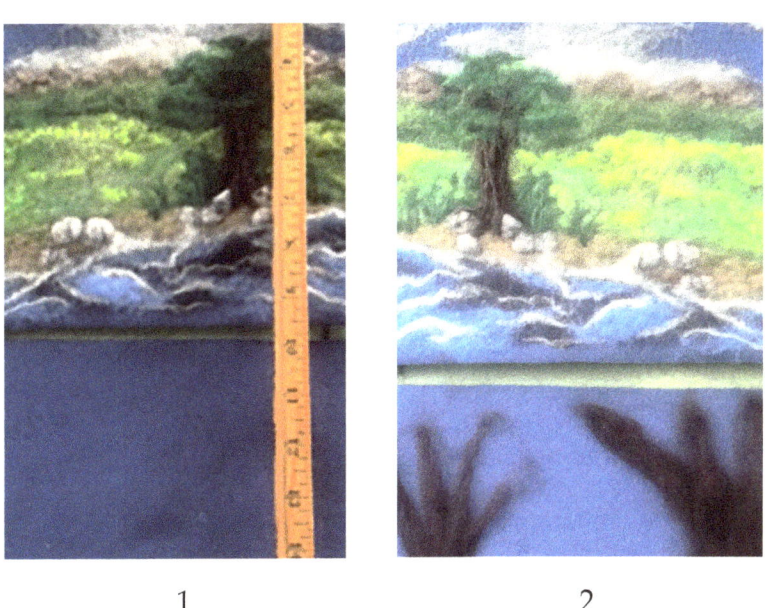

1 2

Photo 2 shows where I plan to put my trees on the new/top layer. I have barely tacked the wool in place at this point, so I can easily adjust it as needed.

Step 2: Create your scene

Use the techniques you learned previously for texture, etc. Add a little brown and several greens for the ground and grasses. Don't forget to add some rocks, too (3)!

VERY IMPORTANT: This layer that you are working on is the foreground and is closer to the viewer. All of the elements that you add to this layer should be larger than the first layer you made.

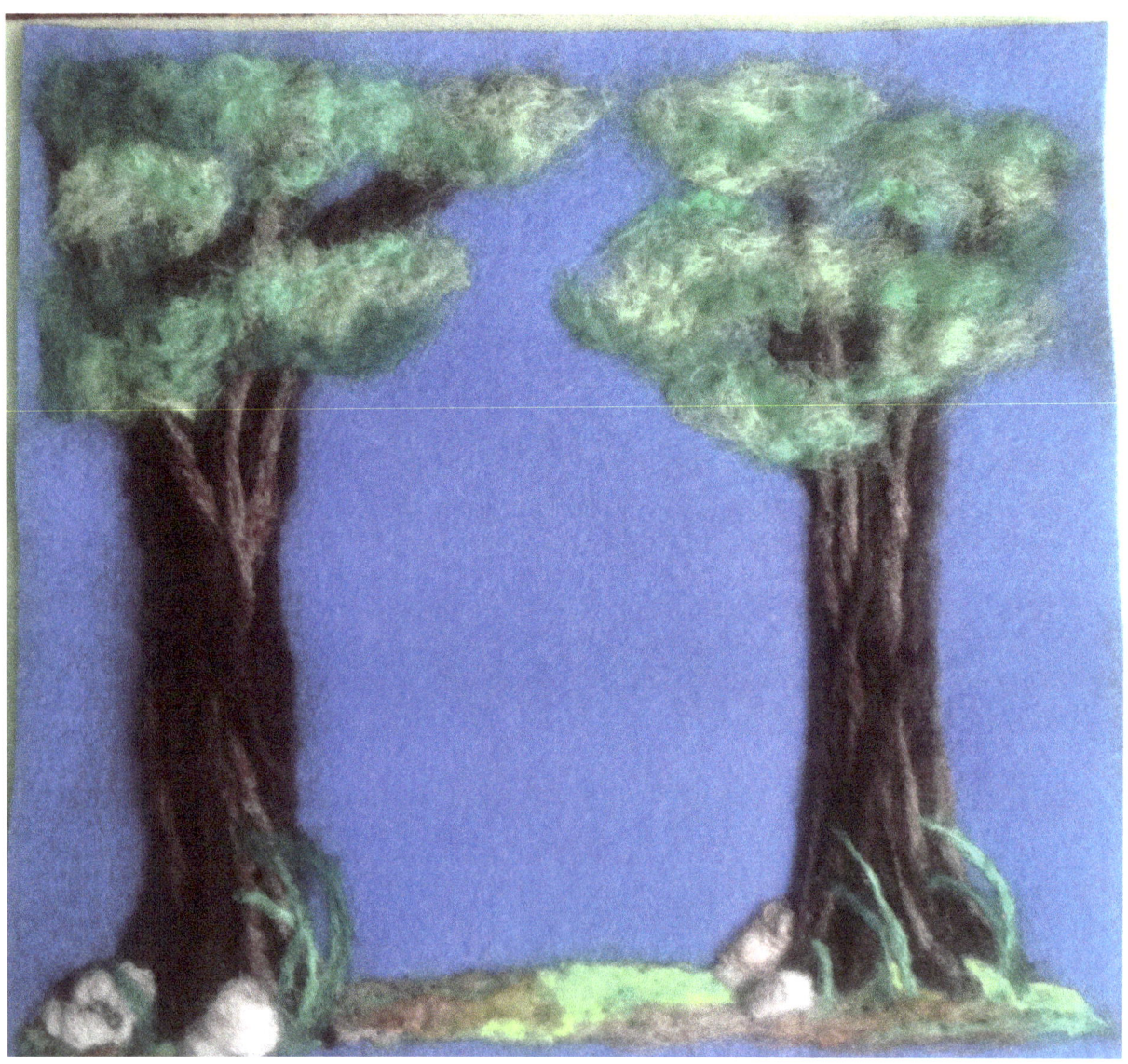

3

Step 3: Cutting

Using a sharp pair of pointed scissors, cut a small opening in the wool. Then lay it on top of the finished piece to see what is visible (4).

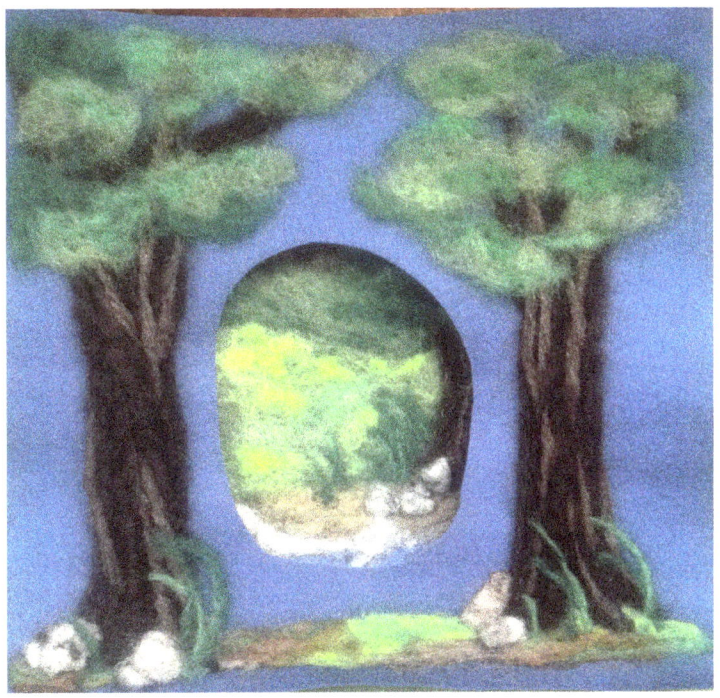

4

Continue cutting away small amounts of the wool felt until at least half of the tree on your first piece can be seen (5).

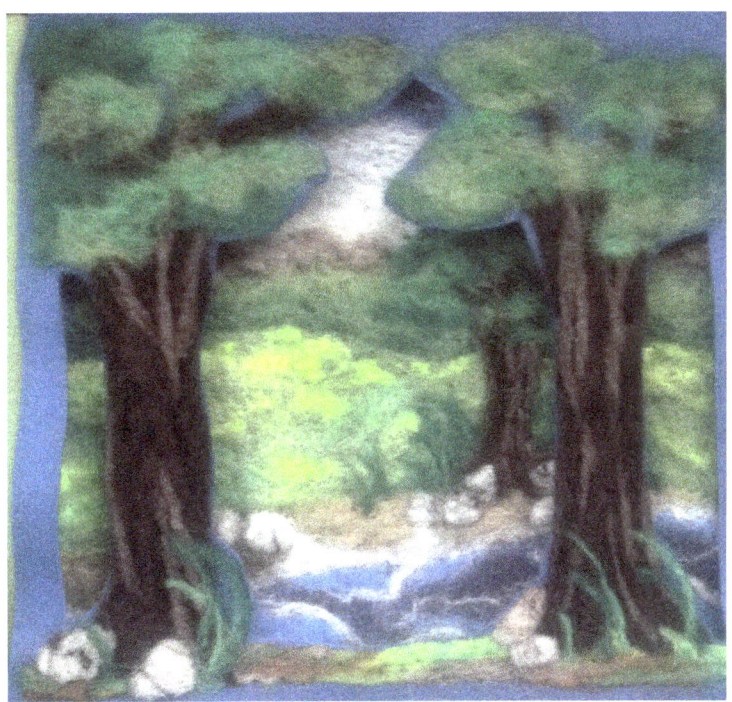

5

Step 4: Hide the wool felt edges

Cut as close to the tree trunks and other elements as possible. You may still notice some of the blue wool felt fabric showing where you don't want it. Fix this by adding and needling a little more matching wool to the area in order to cover and even wrap around the edge (6).

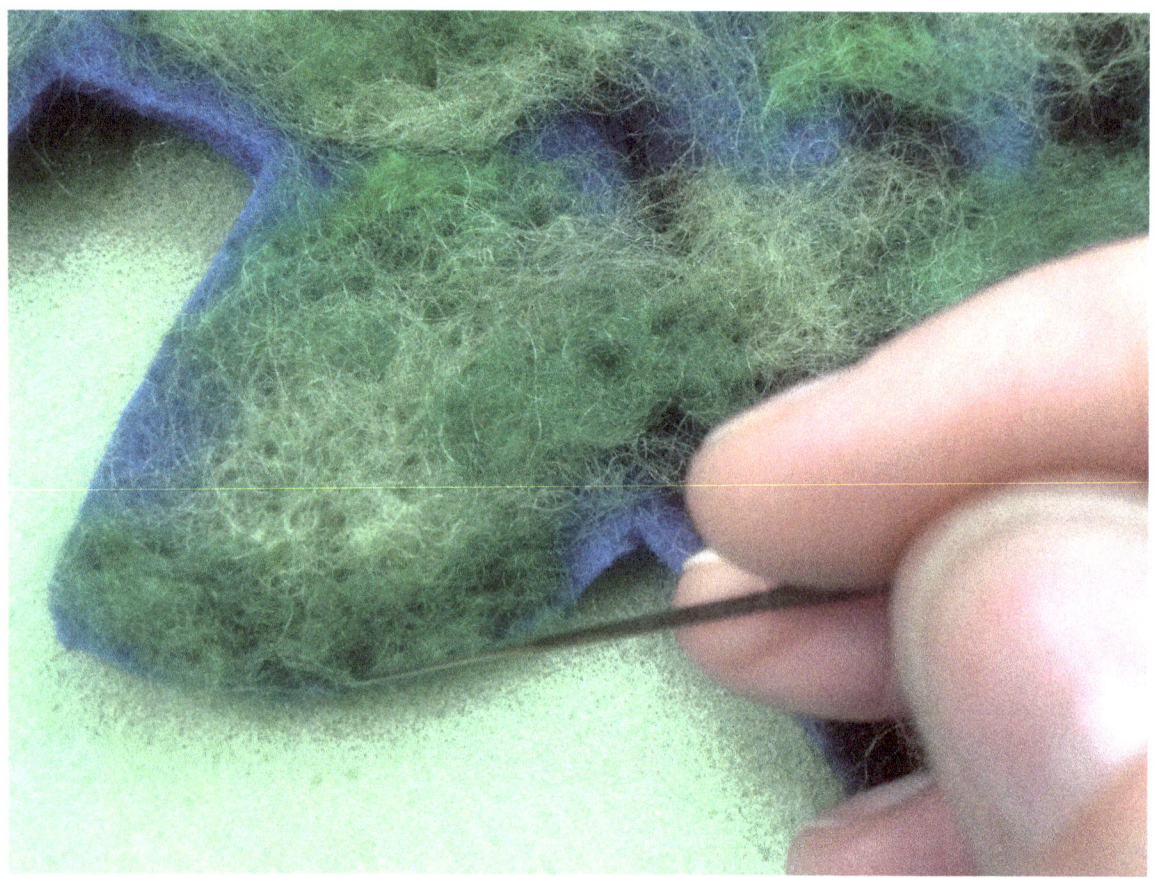
6

Step 5: Assembling the layers

Once your second layer is complete, it's time to assemble your piece. You'll need spacers between the layers at the corners, and possibly other areas too. Use the technique you learned when making rocks to make small bumps in the colors at the corners **of the original layer**. Example: The top right corner of my first layer is blue, so the bump will be blue (7).

Needle the bump onto the first layer very lightly. Then place the second layer on top and needle straight through the second layer into the bump and first layer. This is sort of like making a felt sandwich: fabric, bump, fabric (8).

7

Add bumps wherever your piece sags and needs support to hold the layers apart. Minimally, you want bumps in the corners and at the midpoint along each side. I often add bumps of wool to hold up foliage on the trees, as well.

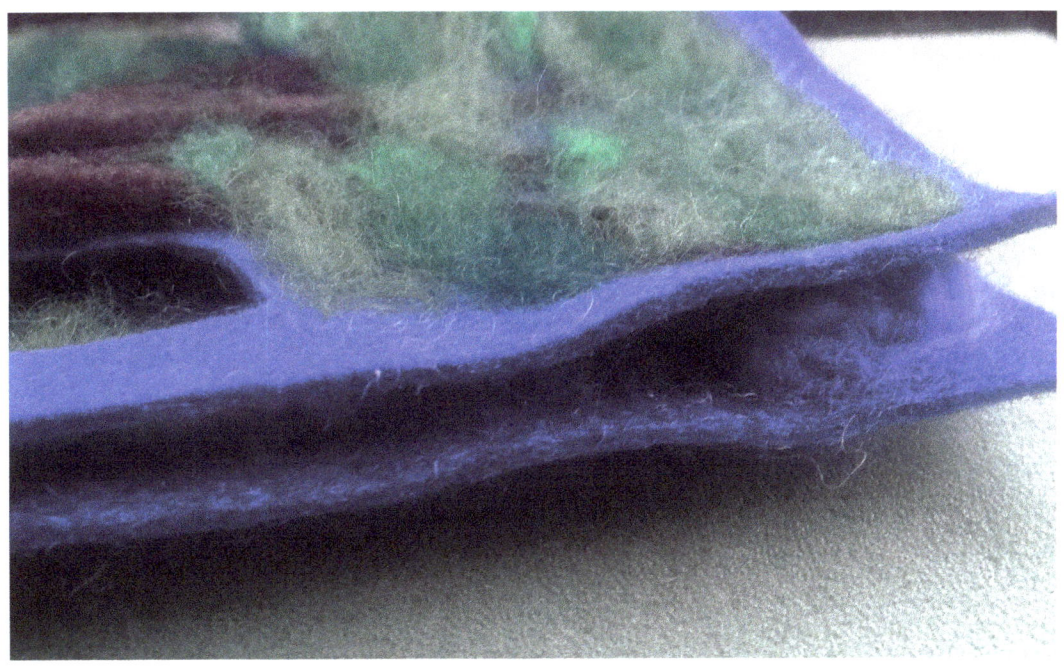

8

Drum roll, please…

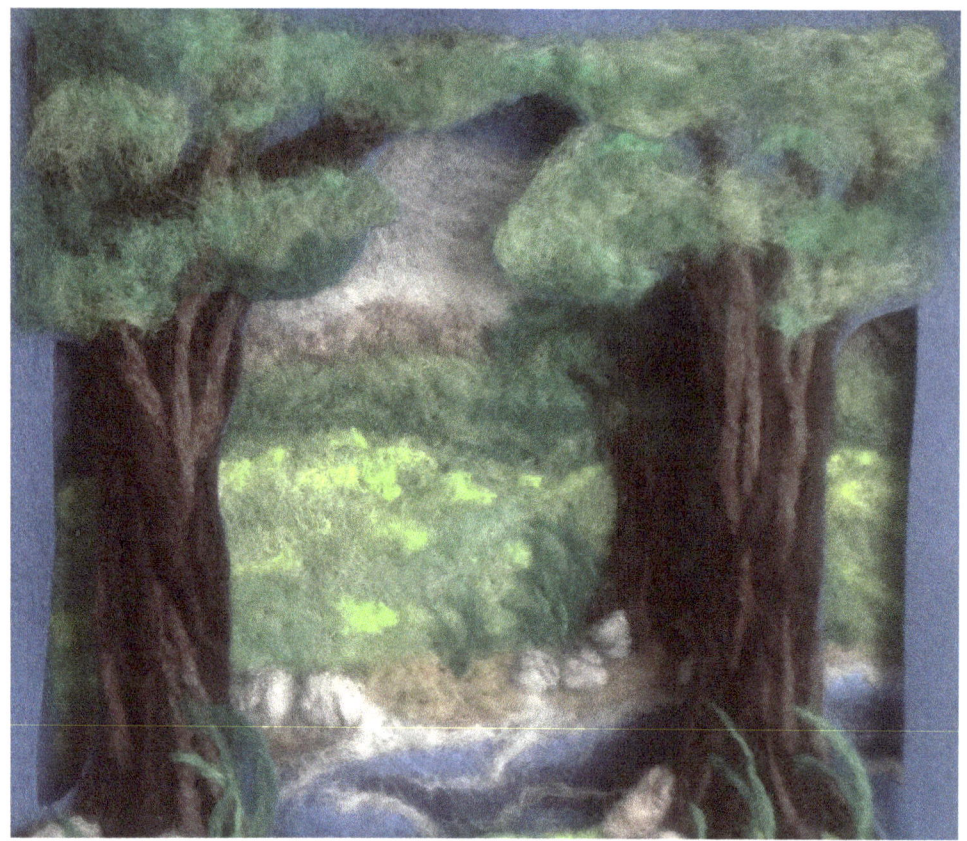

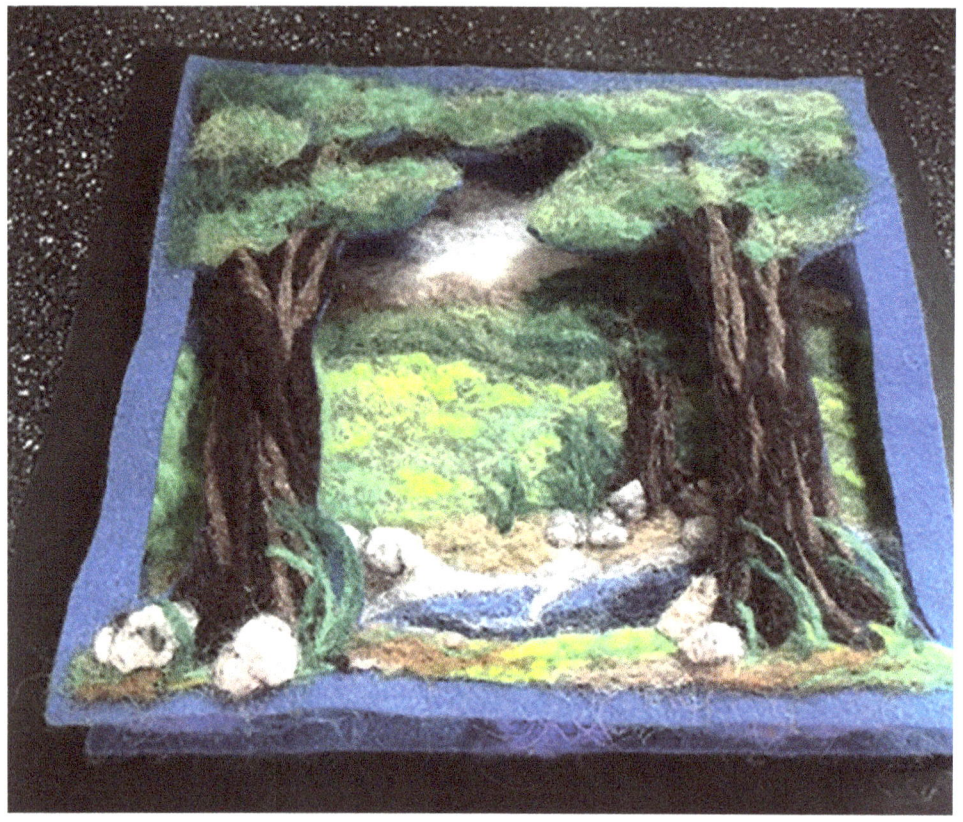

One more example:

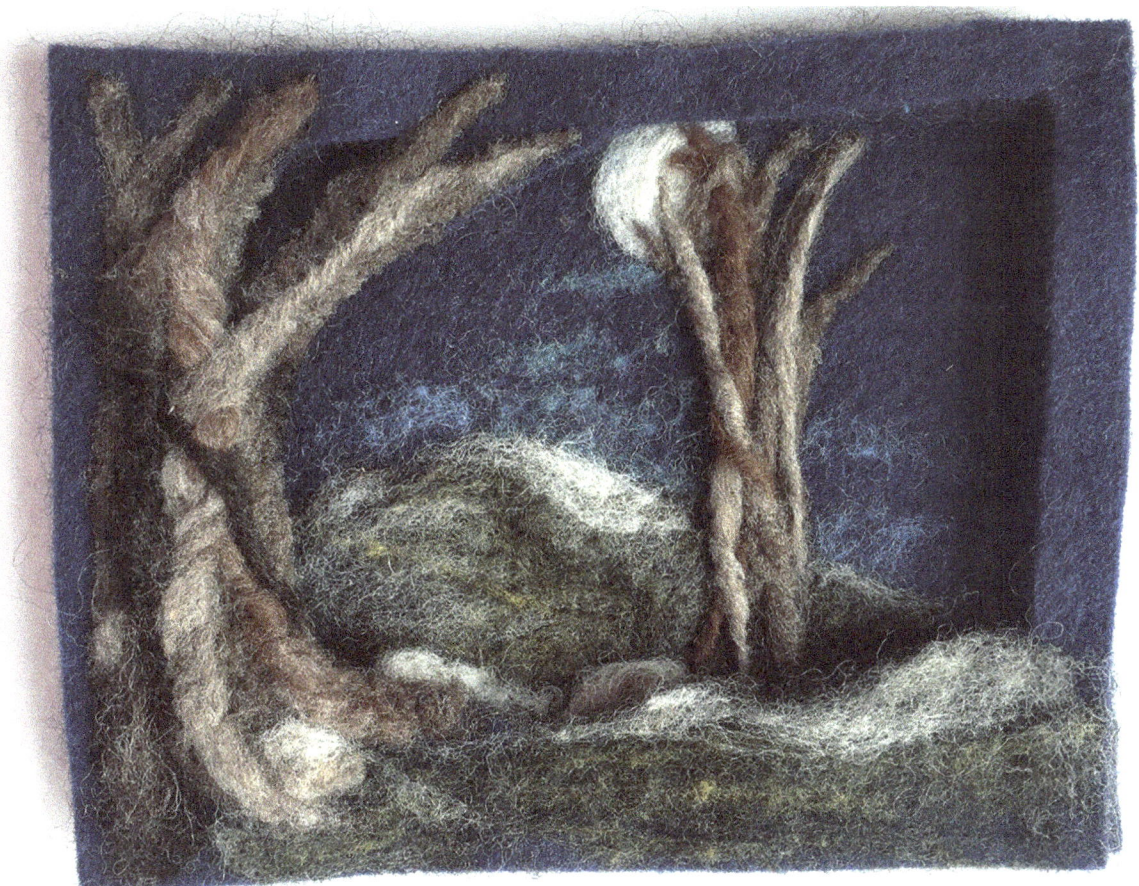

Chapter 5

Hard Days

Some days are just hard. Right?

Whatever you touch slips through your fingers, crashing to the floor.

If there's something to trip over, you'll do it.

Your words aren't coming out right. In fact, maybe you're not even thinking clearly at all.

The best description I've heard for this kind of day is this: "You're not in your body." Yes. That's it. You're preoccupied or tired or whatever, to the point that you are not really present.

During my healing journey, the idea of layers was often on my mind. There were days when I'd feel good about finally tackling a particular issue. I'd think, *Wow. I've dealt with that hurt. I've even spoken with the person who hurt me about what they did.* And BAM! I'd end up having to deal with the hurt once more as the same feeling was triggered yet again…

…maybe in a different circumstance…

…maybe different people involved…

…definitely another LAYER.

Next thing I knew, I'd be dropping and tripping and not thinking clearly, unaware of what my body was doing.

that. darn. onion.

With those kinds of days in mind, I wanted to give you a simple, layered project—something you'll be able to accomplish even on one of those "not in your body" days. And if you've never wet felted before, it's a good starting point.

In the next section, I'll show you how to create layered beads. They're easy, fun, and a great introduction to wet felting with water and soap. They're also small, so there's not a lot to manage. Then I'll show you how to alter the beads a bit and string them to make beautiful felted jewelry.

Chapter 6

Take a moment:

This project, though simpler than the last, can still be something that takes you to a deeper place. Felting, for me, is a meditative activity. While you are rolling the wool in your hands, perhaps you can let your mind wander to more than the task list on the counter or the "I should be doing" lists we all have in our minds. Perhaps watch your hands as they move and be amazed at how miraculous our bodies are that they can move in the ways they do. As you play with different color combinations, enjoy the creativity that is pouring out of you.

Layered Beads

What you need:

- wool roving in 2-3 colors
- hot water in tub/basin
- soap (*see note below)
- scissors
- skewer
- needle
- monofilament or other stringing thread
- clasp of your choosing
- glue (optional)

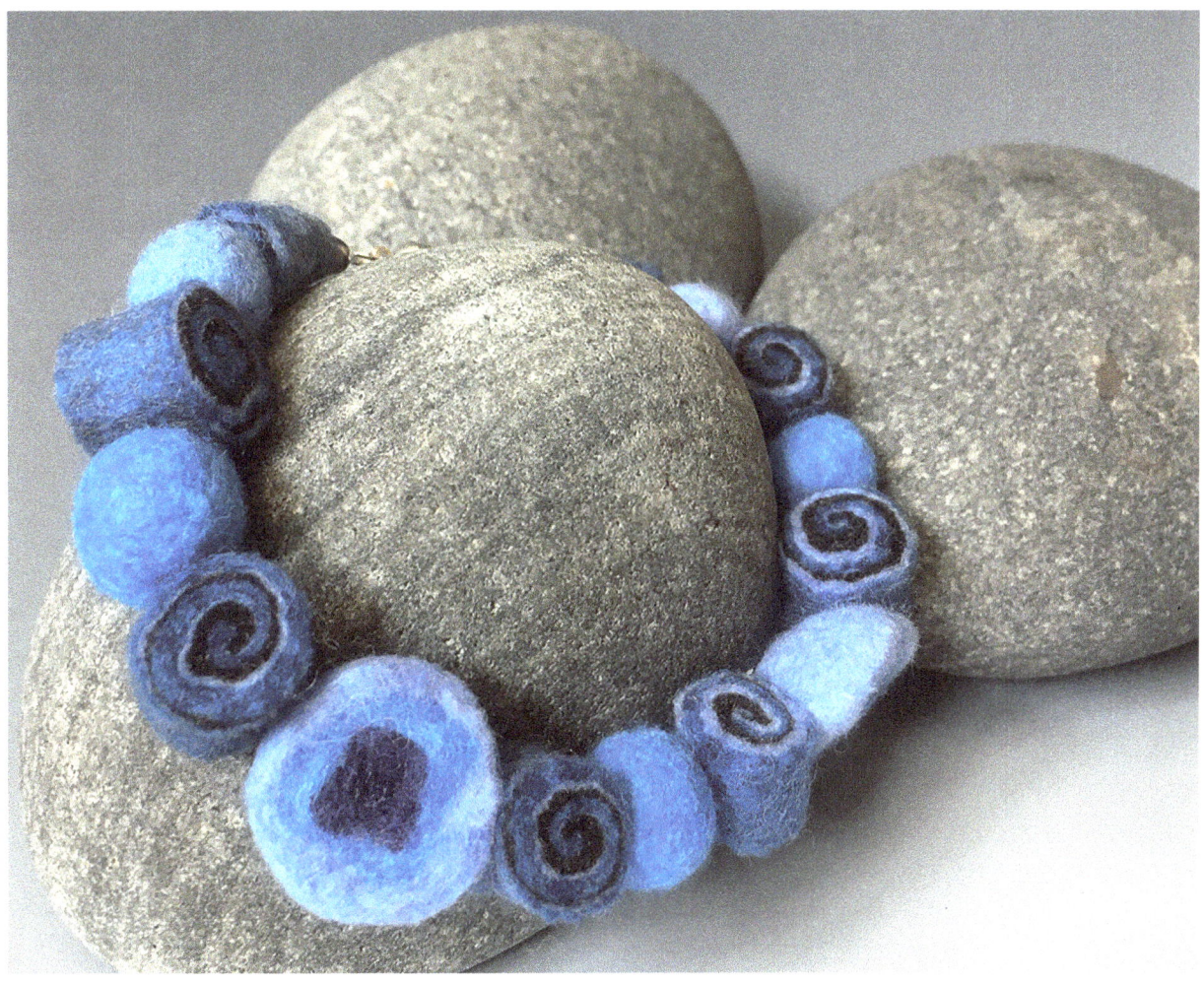

Step 1: Preparation

Fill a large bowl or basin with hot water. This water should be a temperature that is hot but still comfortable to your hands. Add about one tablespoon of soap to the water.

*****A word about soap:** There is a lot of information about what type of soap is best to use for wet felting. I have tried many different types and can tell you that there is no real difference in how they perform. I've used bar soap, liquid dish soap, olive oil soap, and even shampoo. They are all great for felting. The only real difference is how your hands will feel afterward. The benefit to using olive oil soap is that it makes your hands feel moisturized after felting instead of dried out, but you do pay more for it.

Shown below are three different colors of wool roving (1). Use whatever colors you would like, but for the purposes of these instructions, I'll simply call them light, medium, and dark roving.

1

The nice thing about roving is that the wool fibers are already "organized" (going in the same direction). Because of this, you can divide it into smaller "ropes" easily.

Step 2: A one-colored bead

Pull off a piece of light roving that is about four inches long. Then separate it into two to three "ropes" so that there isn't too much wool in your hand at one time (see amount of wool in photo 2).

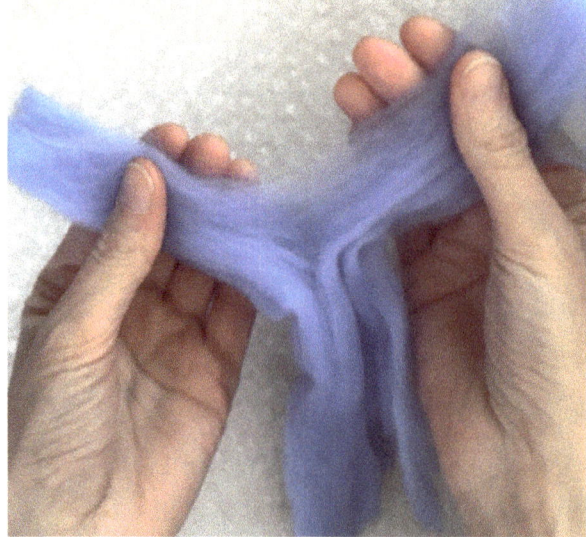

2

Gently pull on the roving, allowing it to slip through your fingers and elongate. Your four-inch length of roving should become six to seven inches long. This is called drafting (3).

3

Step 3: Rolling

Take the drafted roving and wrap it around your finger a few times (4).

4

Slip the roving off your finger and roll it tightly almost to the end. You'll notice in the next three photos that I turn the ball that is being formed back and forth to try to evenly distribute the wool around the ball and get the smoothest surface possible (5-7).

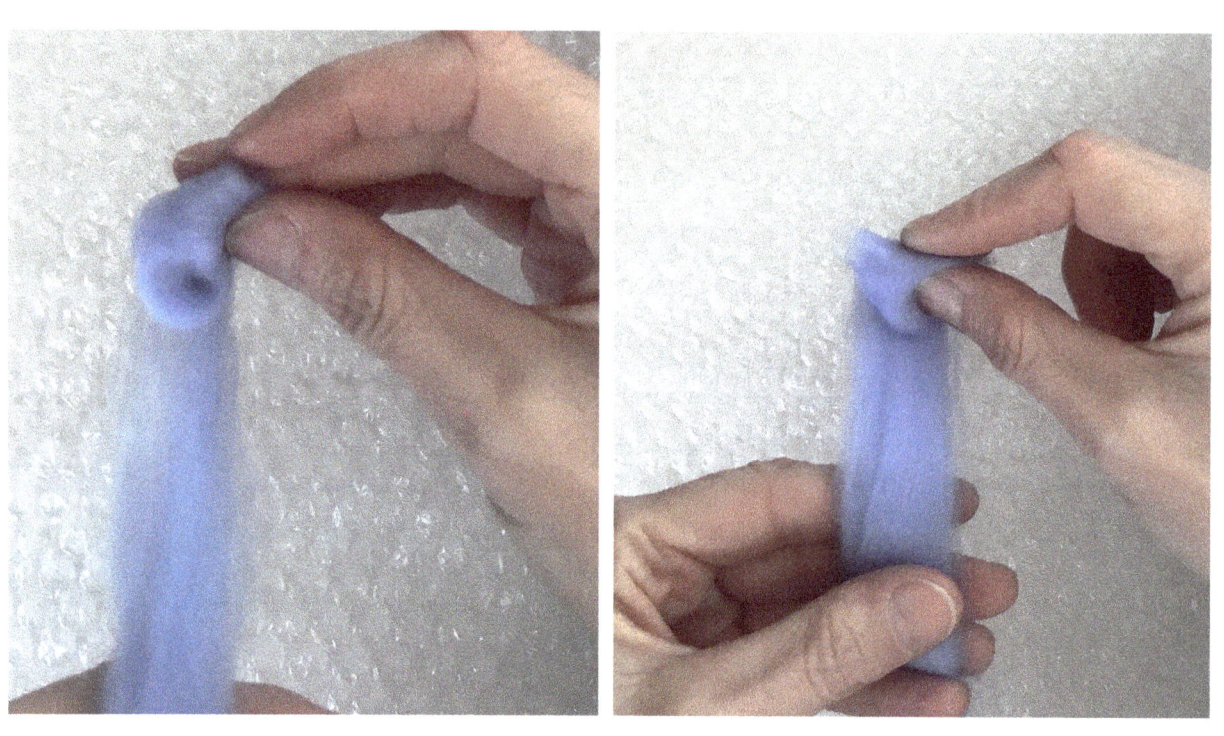

5

6

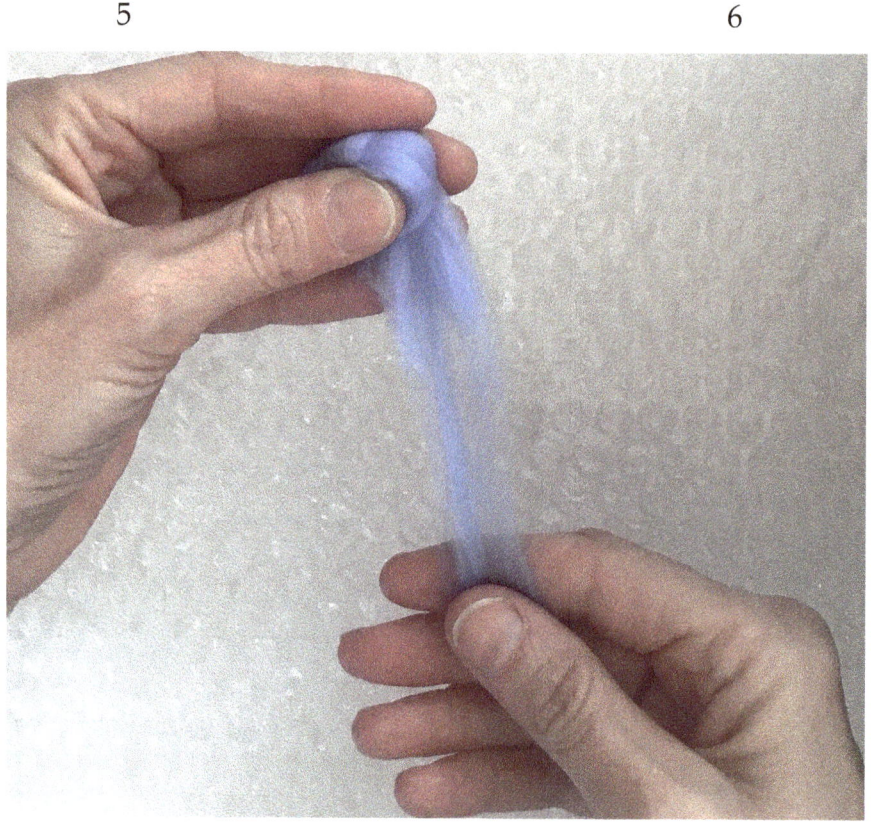

7

At the very end of this rolling step, carefully wrap the last fine fibers all the way around the ball (8). These last fibers will help to hold it together.

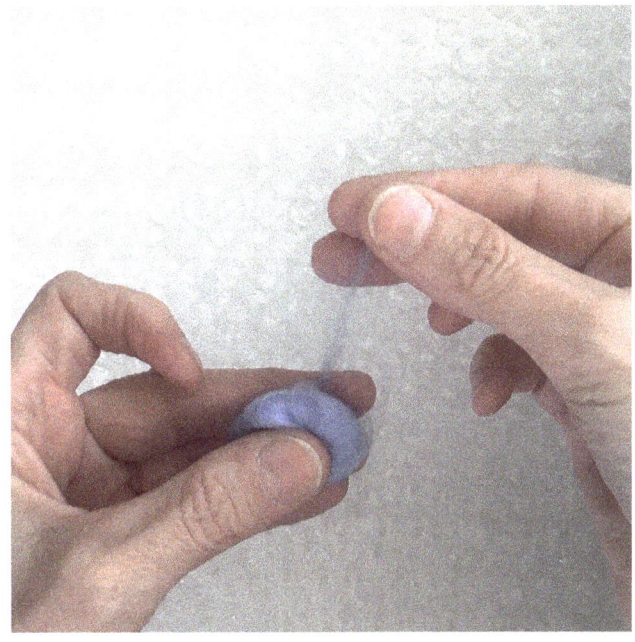

8

Step 4: Felt the wool

Submerge your ball into the soapy water (9) **WITHOUT LETTING GO OF IT**. I like to hold it underwater and let the air bubbles inside the ball finish bubbling to the surface of the water before lifting it out of the water. At that point, I know that the inside of the ball should be pretty well soaked all the way through.

9

This next step is the one you need to listen to the MOST!

Gently,

Gently,

Gently,

begin rolling the ball between your hands (10). You should feel as though you are not accomplishing anything; that's how light the pressure is on the ball. Keep it moving this way for about five minutes. Now and again, dip the ball into the hot water and put a tiny bit of soap on your hands.

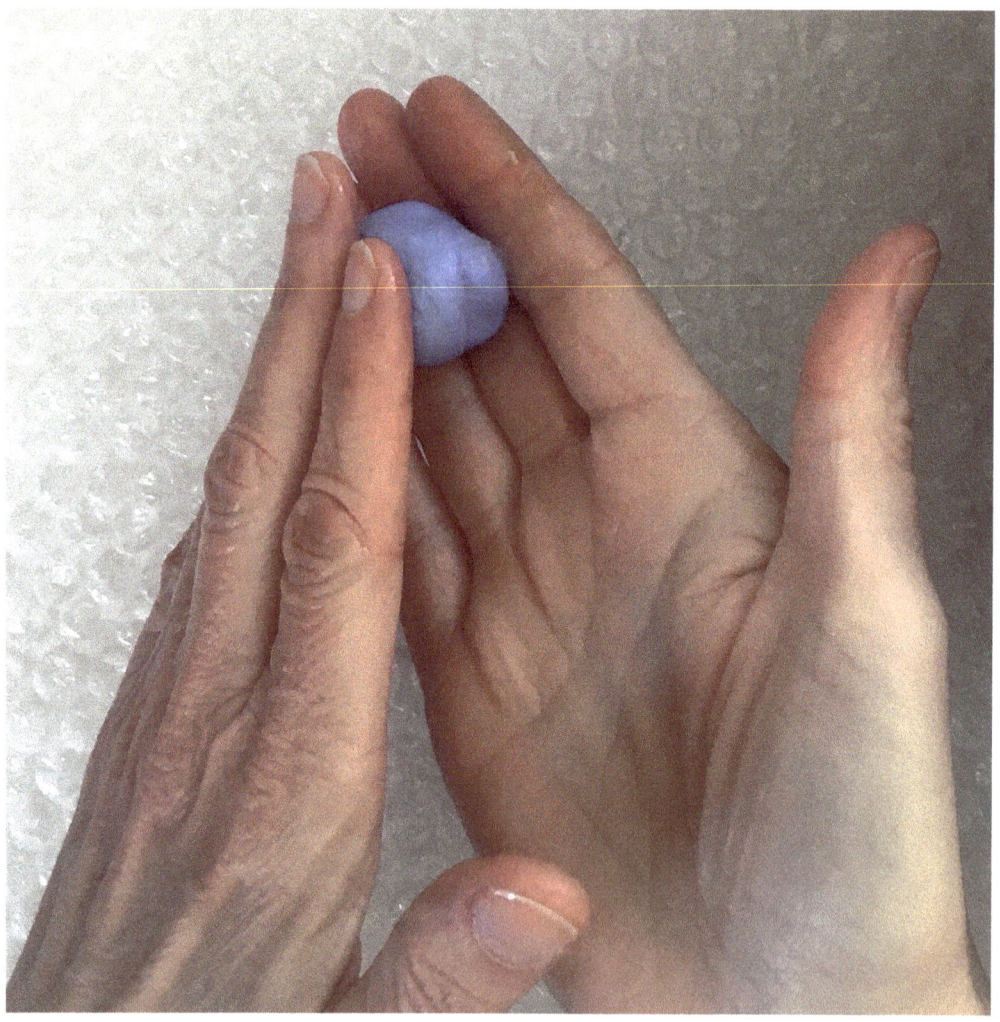

10

When you begin to feel the surface of the ball hardening, meaning it's starting to felt, you can progressively put more pressure on the ball and roll it more vigorously (11). Eventually, you will have a nice, solid, hard wool ball.

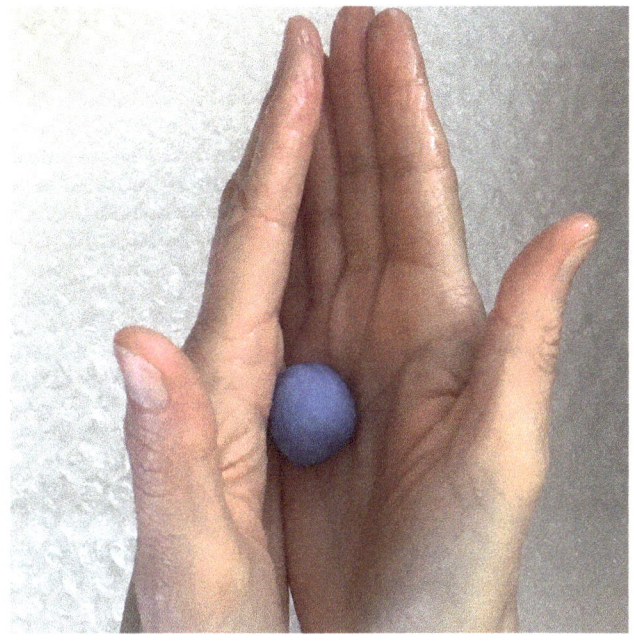

11

What happens when you put too much pressure too quickly on your wool ball? It gets wrinkles and craters like this (12):

No one wants this, so work

s l o w l y

as you felt.

12

The next two photos (13 & 14) show the shrinkage that occurs during the felting process. Isn't it amazing that this ball shrunk to just about half its original size? That's felting!

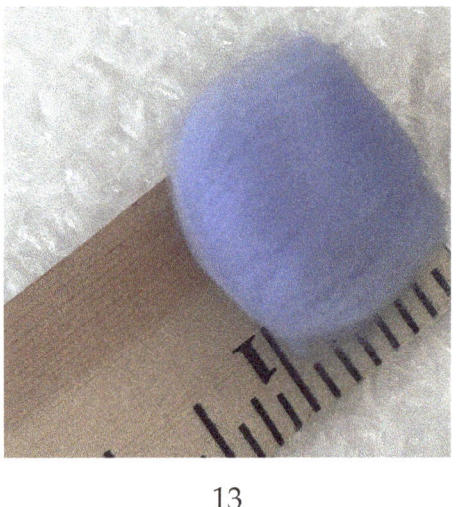
13

14

Make a few more balls until you feel you have the hang of it.

Too much soap or not enough? If you see a lot of bubbles and suds, you have too much soap. Too much soap will actually keep the wool fibers away from each other, not allowing them to connect and felt. If your wool gets a hairy appearance as you are moving it between your hands, you most likely don't have enough soap and water involved in the process.

Step 5: A layered bead

Draft a small amount of your dark roving (15) and wrap it around your finger. Slide it off and continue rolling tightly until you have a ball that's just a bit larger than a pea (16).

15

16

Step 6: Add layers

Using the medium-colored roving, pull off a bit more wool than you did in the last step (17).

17

Place your dark roving ball onto the end of the medium roving (18). Roll the medium roving around the dark ball, turning it this way and that to totally cover the dark ball and get a smooth surface (19).

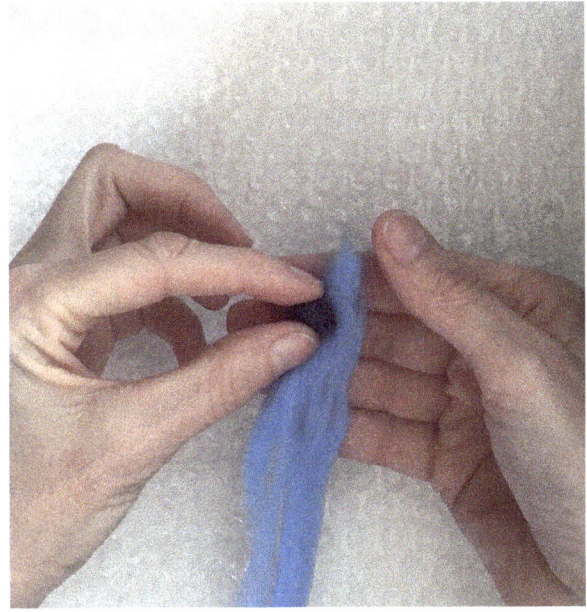

18

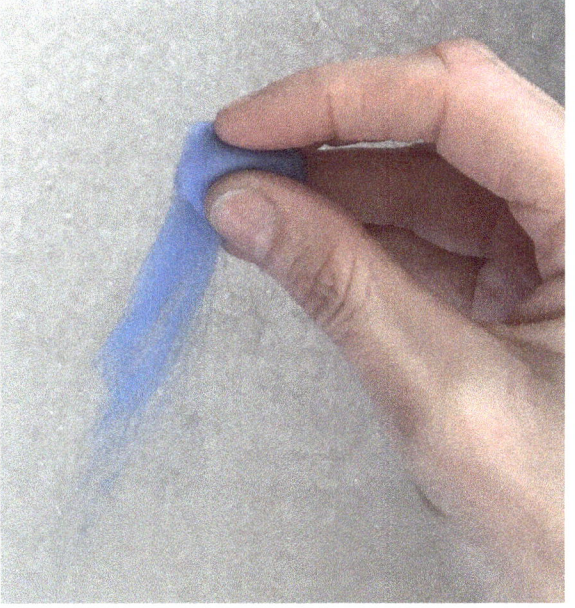

19

Now, draft some light-colored wool (20). Use a bit more than in the last step. Place the medium ball on one end of the light roving (21) and roll the ball up, again turning it this way and that way to get a nice, even surface (22).

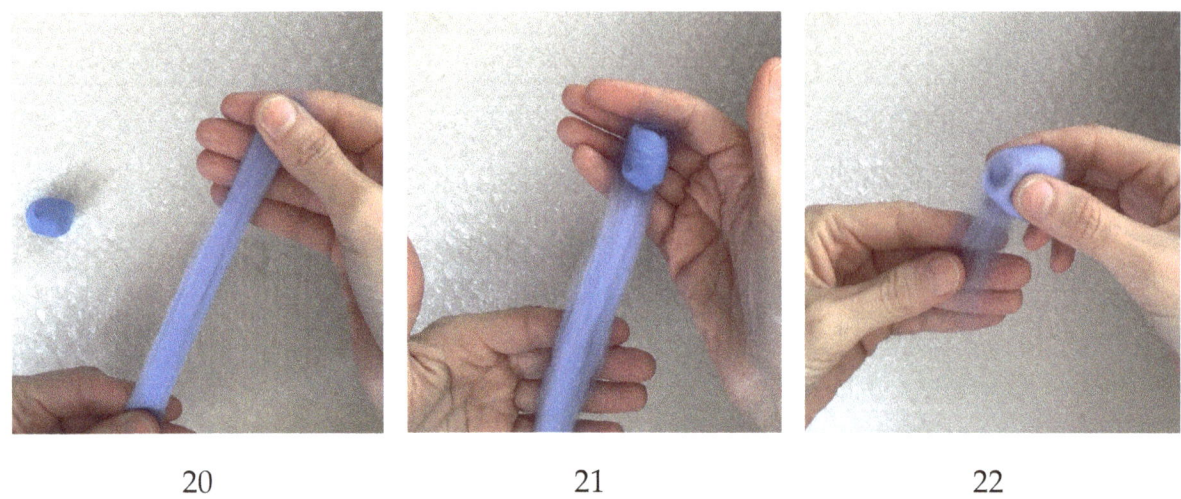

20 21 22

Step 7: Felt the bead

Submerge the ball in the hot, soapy water and lightly roll it as before (23). Remember to go gently.

23

Make a few more round, layered beads, changing what color is on the outside and inside. Experiment.

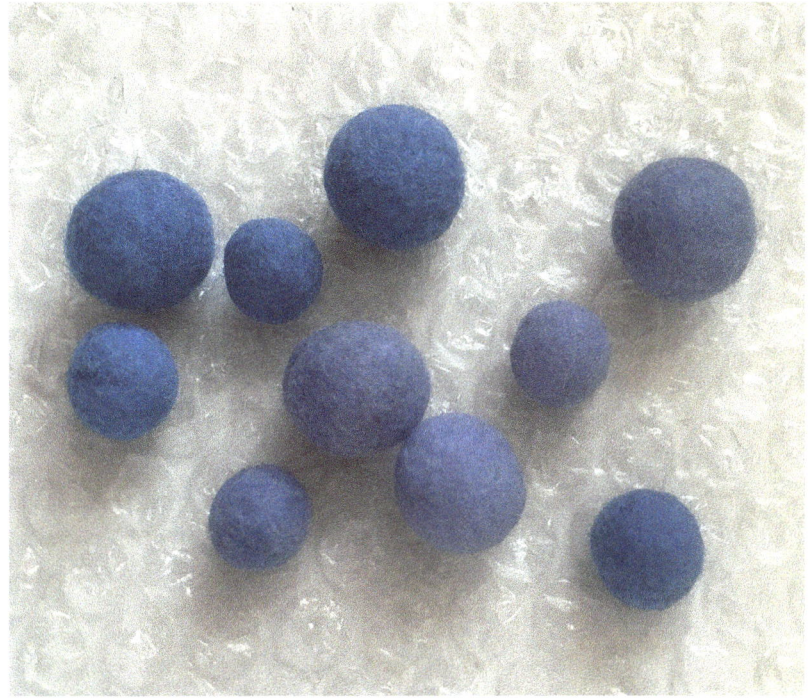

*Keep your layered beads separate from the solid-colored beads so you know which ones you may want to cut in half in the next step.

Step 8: Cutting your beads

Using sharp scissors, cut one of your layered beads in half (24). It's fun to see how the inside of the beads turn out (25).

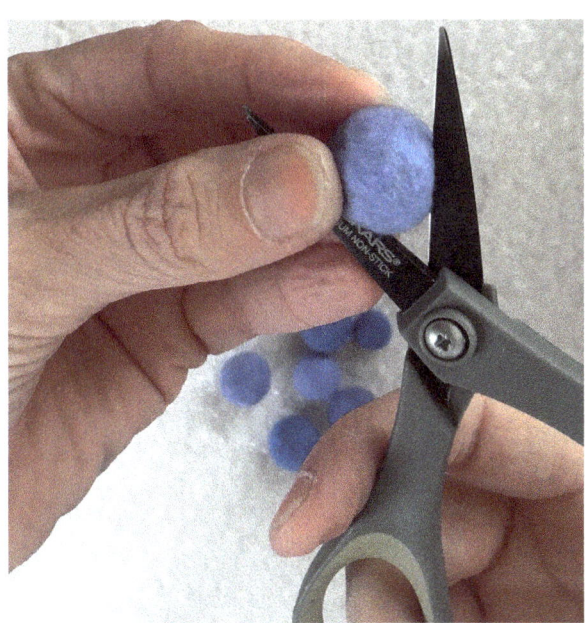

24

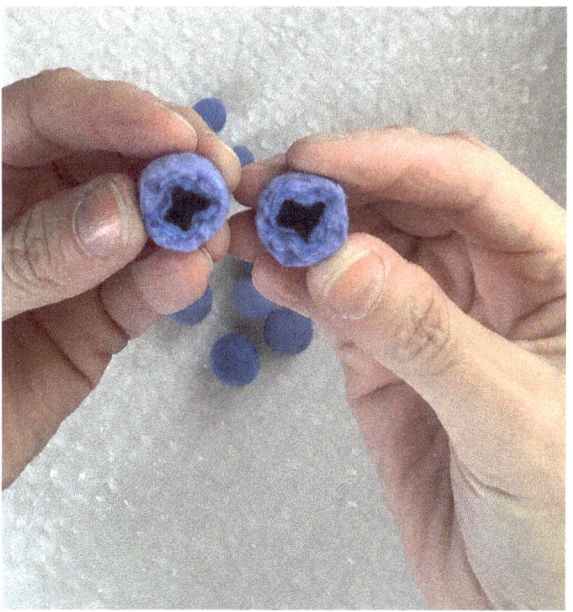

25

With a little soap on your hands and a bit of water, roll the bead halves in your hands for a minute or two to round out the raw edges from where you cut the beads open (26). This will give them a nice, finished look.

26

Step 9: Making Sliced "Log" Beads

Gently pull out small amounts of medium roving and lay them side by side on your work surface (27). Make a row about three inches wide.

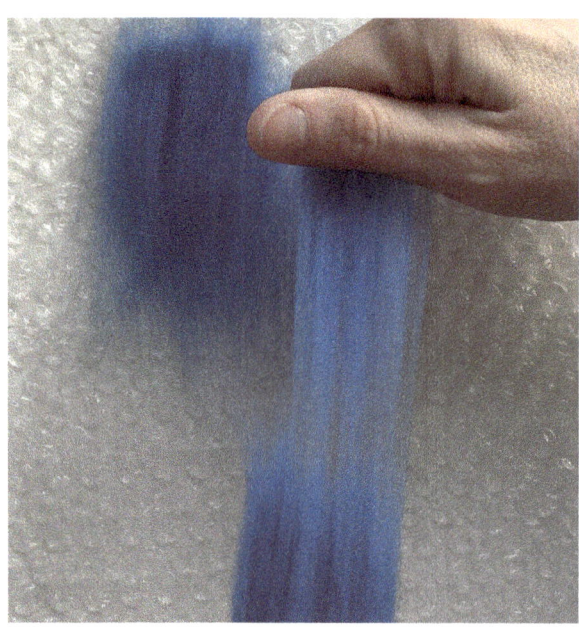

27

Step 10: Add layers

Add a second layer of wool with the light roving right on top of the medium wool (28 & 29).

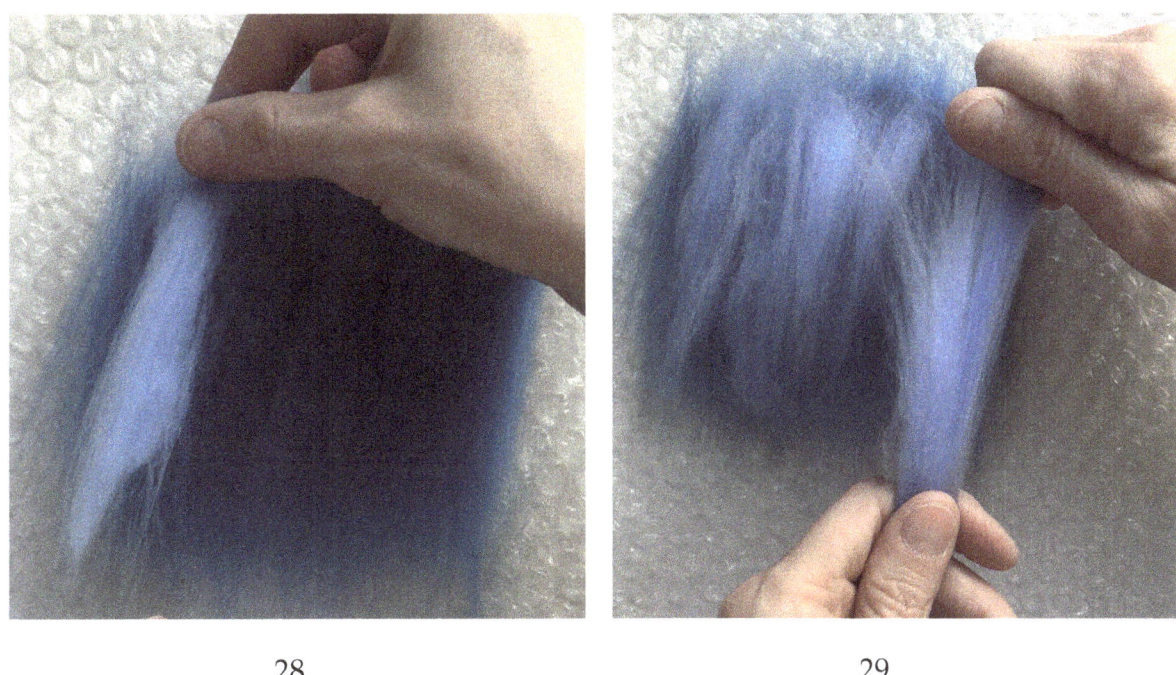

28 29

Add a third layer of wool on top of the first two using the darkest wool (30).

30

Step 11: Rolling the log bead

Lay a bamboo skewer across the edge of the stack of wool. The skewer should be perpendicular to the wool fibers (31).

31

Carefully wrap the wool around the skewer (32). It's easiest to leave the wool on your work surface as you roll up the wool.

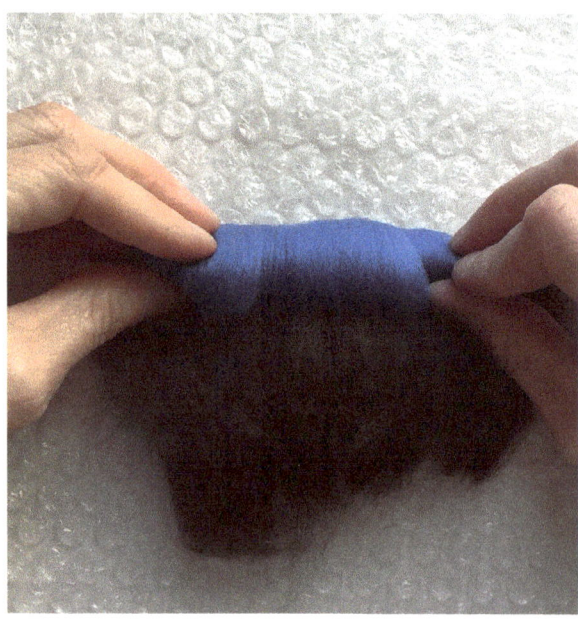

32

Slide the skewer out of the wool roll (33).

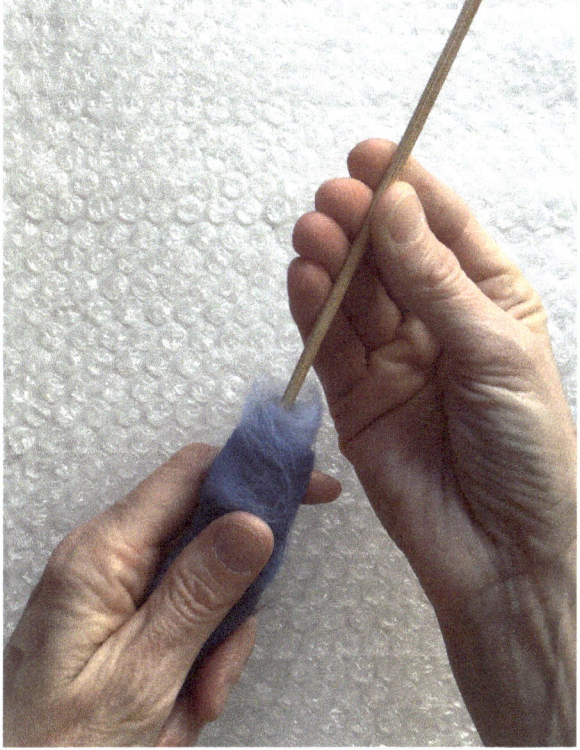

33

Step 12: Felting the log bead

Hold your wool under the surface of your hot water until the bubbles stop coming out of it, as you did for the round beads (34).

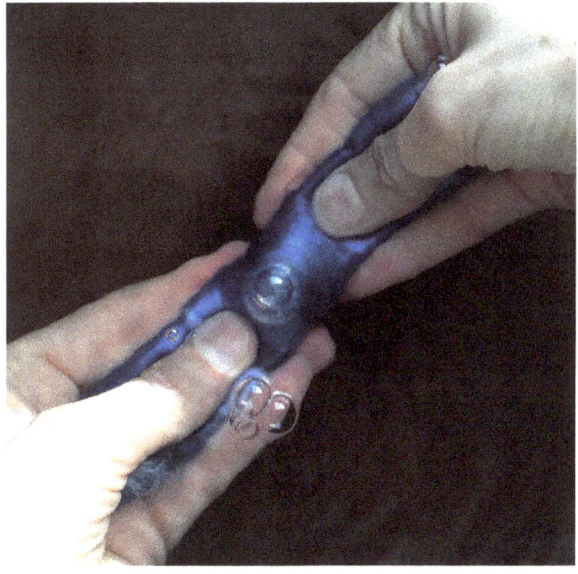

34

With a little soap on your hands, carefully lift the roll from the water and gently move the roll from hand to hand, putting very little pressure until the outer "skin" begins to form (35). This will take five to ten minutes, so be patient. If you see wrinkles appear in the wool, use soapy fingers to spread and smooth the wrinkle in that area out. Then return to moving the roll back and forth (36).

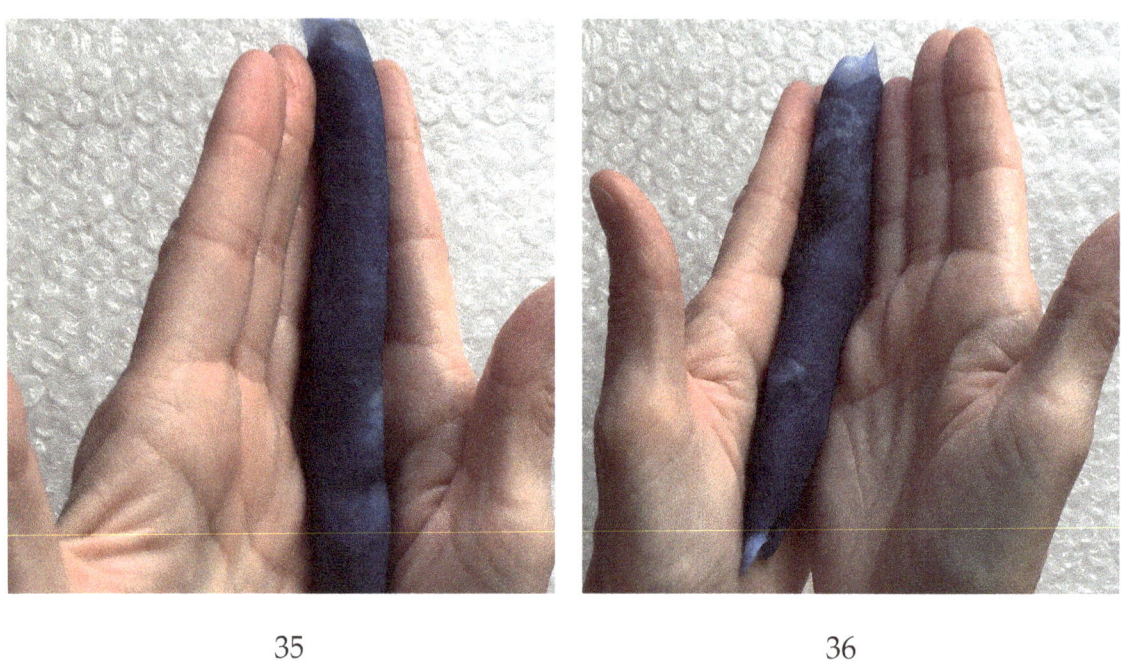

35 36

Once you notice the roll shrinking and can feel it felting, you can begin rolling it on your bubble wrap (37). Keep your roll moving, dipping it in the hot water periodically and adding a little soap to your hands now and then.

37

Your roll should shrink to approximately half of its original width (38 & 39).

38

39

Step 13: Cut the log bead

Using sharp scissors, cut lengths of the roll into beads (40). Don't go smaller than half-inch lengths, or your beads may not hold together well. By layering and rolling up the wool in the beginning, see the lovely spiral that can be created? (41)

40

41

Step 14: Stringing your beads

Lay out a design with your wool beads that you find pleasing. Maybe an alternating pattern or a totally random style suits you. Thread the monofilament (found in the bead section of craft stores) or other bead-stringing thread onto your needle and begin stringing your felted beads (43).

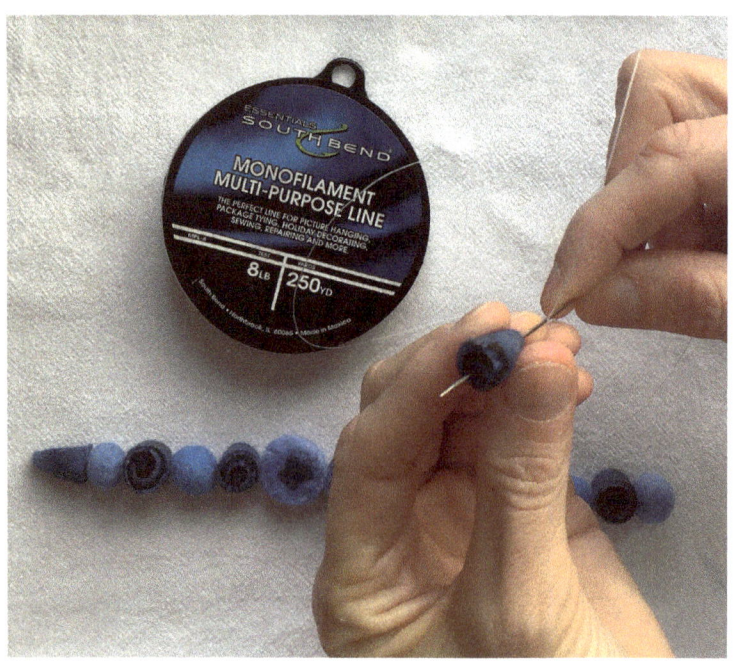

43

Once the beads are strung, remove the needle and make a tiny loop on one end of your string (44).

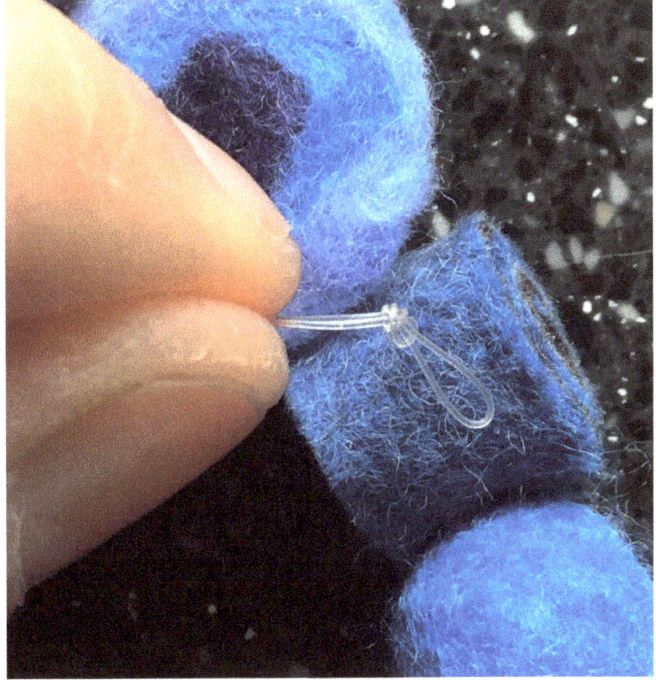

44

Open a jump ring, as shown. Opening them side to side, as shown, rather than pulling them into a "C" shape helps to maintain the nice roundness of the ring when you close it back up (45).

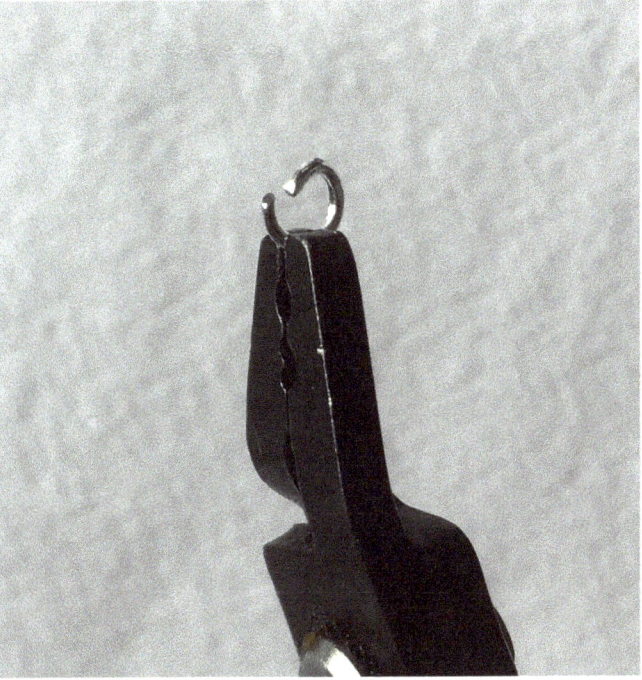

45

Put the jump ring through the loop in your monofilament (46) and add a clasp of your choosing (47) to the jump ring, as well. Close the jump ring.

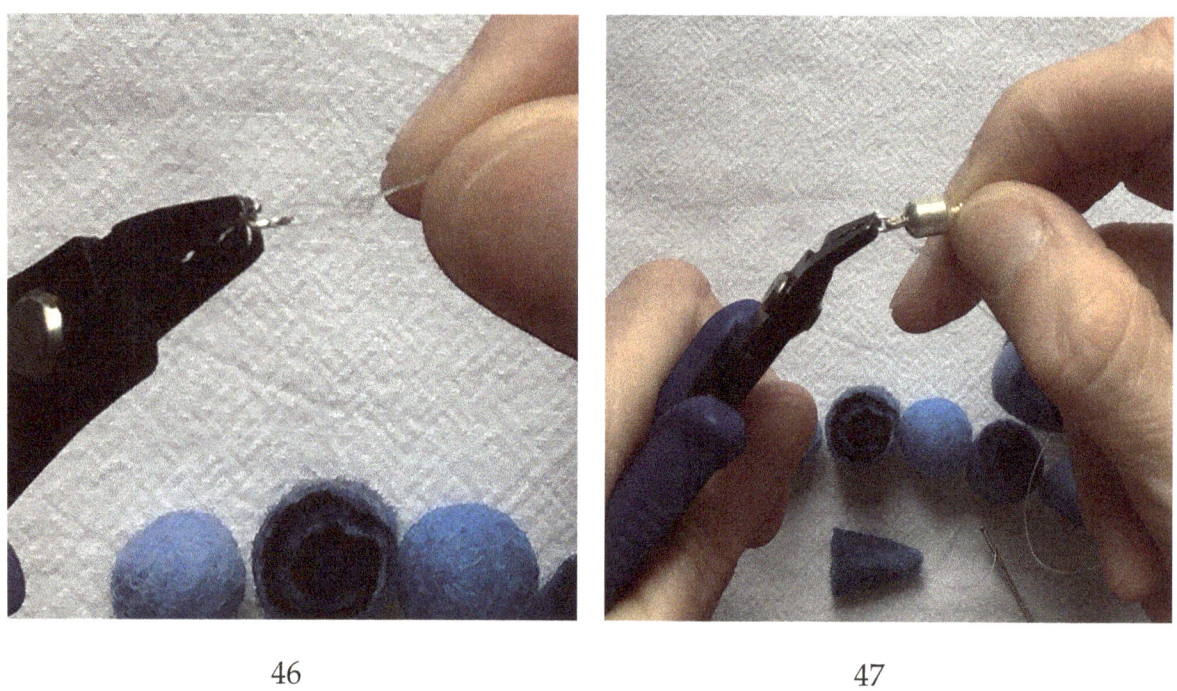

46 47

Optional: Add a tiny drop of glue to the knot you made to be extra sure your monofilament will stay secure (48). Let dry according to the instructions on the glue. Trim the extra monofilament, leaving a small quarter-inch tail.

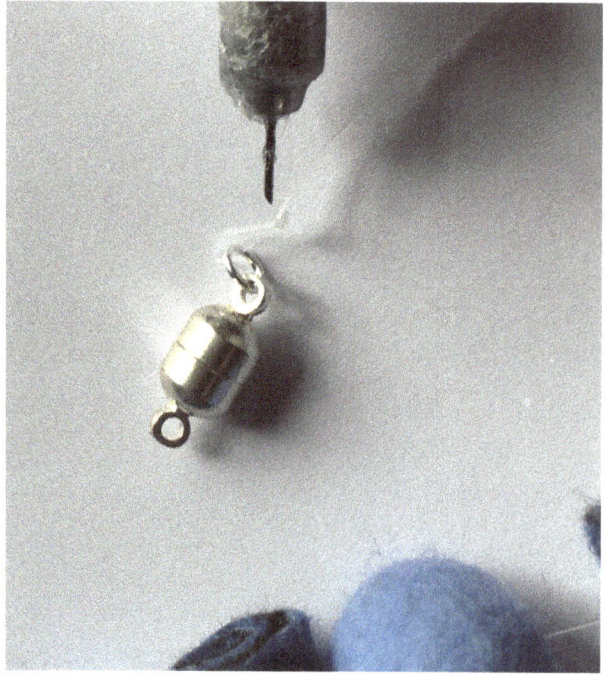

48

On the other end of your bracelet, follow the same steps, making a loop and adding the jump ring, clasp, and a dot of glue (49).

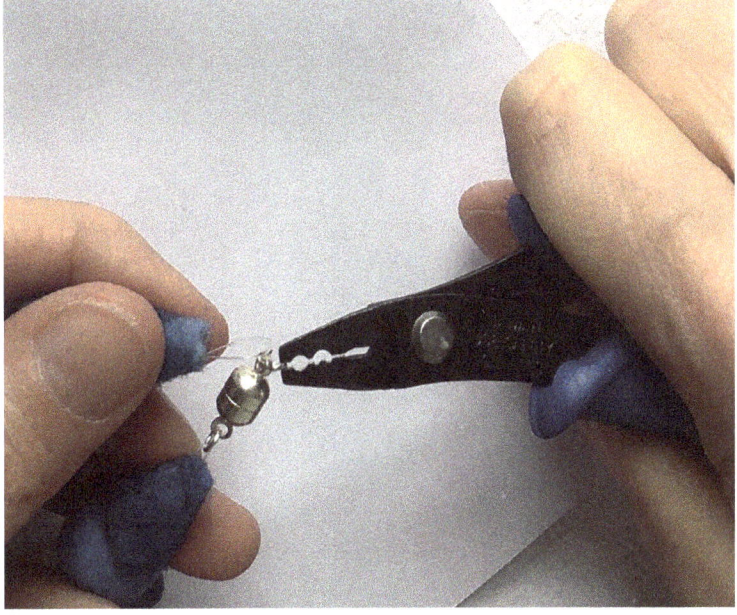
49

Additional tips: If too much of the monofilament is showing after you created your knot, add one or two metal or glass beads before you add the jump ring and clasp (50 & 51). Adding these beads can finish it off beautifully.

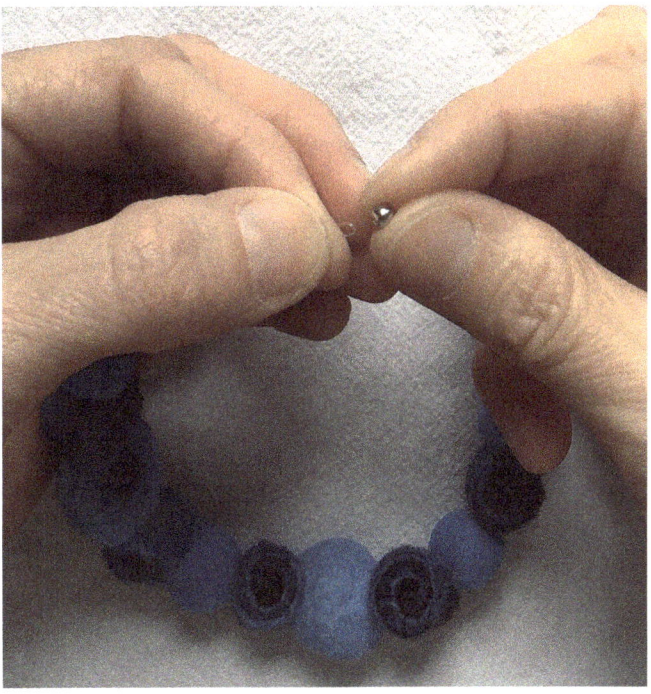
50

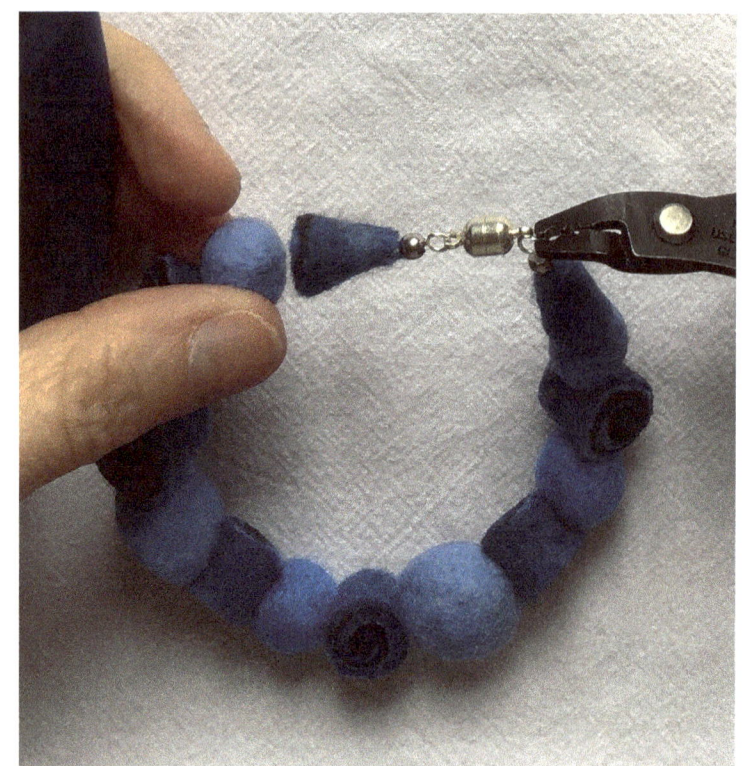

51

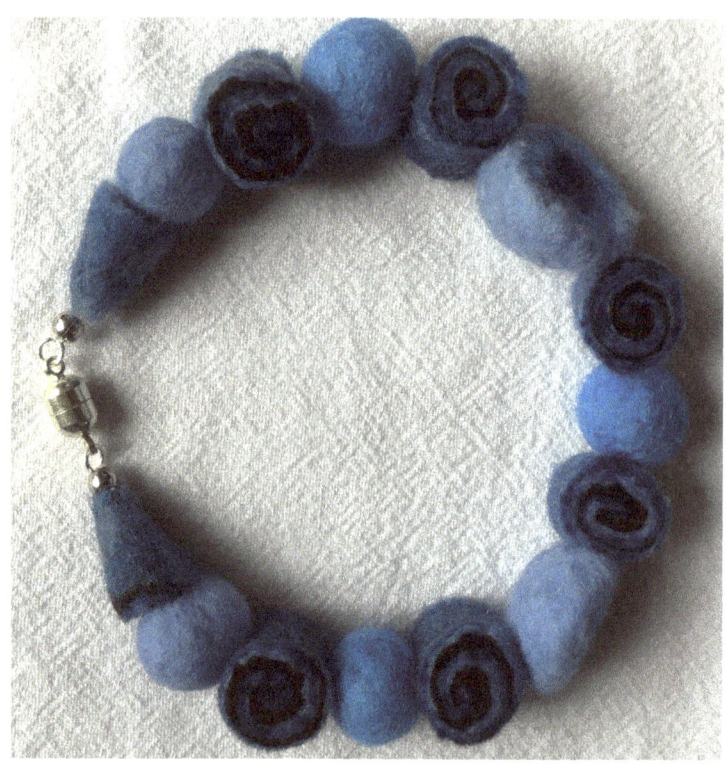

Lovely!!

Retreat

Chapter 7

What is a retreat? Why go on one?

Search the internet, and you will see a myriad of retreats (spiritual, corporate, silent, and yoga, to name a few) and article after article about the benefits of going on one. It boils down to this fact: Humans need to disengage from the hectic pace of life from time to time and look inward.

Have you ever gone on a retreat? If you can—and I know it takes time and often money (though there are creative, free solutions to this)—I highly recommend taking time out for yourself on a personal retreat. Having time alone in a quiet place to rest, to sort your thoughts and feelings and hopefully re-energize, is priceless.

It doesn't have to be out of reach financially. In fact, here is another opportunity for creativity. Camping, swapping houses with a friend, or watching someone's children so they can have a retreat day and then having it reciprocated…there are many ways to retreat, even if it's for just a few hours. Once you've done it yourself, you'll be hooked.

My Retreat

My special retreat location is an island off the coast of Maine called Monhegan Island.

Monhegan Island has been an artist colony since the 1850s. I've found a reasonable cabin to rent, and I bring most of my meals so I can cut the cost and, more importantly, simplify things so I can better focus on the whole experience.

For me, once I begin planning meals, shopping, and cooking, I lose my focus. I go bare bones, which horrifies some of my friends. But I figure a diet of sardines, crackers, oatmeal, and ramen noodles for a week or two each year won't kill me. I've tried to work out a better meal plan, but as I said, it takes the focus away from the inner and artistic work I like to do while there.

a little stretching on the bluffs on Monhegan

I take a retreat because it's the only way I know to quiet my mind, to stop the inner dialogue, and to truly slow down!

Do you have that dialogue, too? It's that voice that evaluates, judges, and narrates. For example, when I look at a house, I think about how I'd change it. I look at a sweater and think about how good it would look on a friend. Or I simply run through to-do lists in my head, which never stops. These all come from the inner voice that needs to be quiet and rest from time to time in order to make room for creative things.

Slowing Down

My first year on Monhegan, I found that it took a few days, but the inner dialogue in my head finally quieted. I found myself sitting and watching a snail—yes, a snail—do its snail thing on a path I was hiking. That's slowing down! There was no "its shell is so pretty" or "I wonder how fast he can move." None of that. I just watched and took it in.

After that, I was on the shore looking for the perfect rock. I believe that because my inner pace had slowed, I began to think beyond finding the perfect rock and instead thought about the never-ending quest for perfection in our lives in general. Slowly, layer by layer, I began to go deeper. A snail. A rock. And then inner exploration.

Chapter 8: Mandala

I know there are times when a retreat is not possible, so developing a meditation practice or time for prayer can be key to staying focused on what you feel is important. It's another way to pause and look inward. This next project may help.

What is a mandala? What is it for? Even though I am a Christian, I have never had a problem incorporating (some might say co-opting) other traditions and symbols into my religious and spiritual life. It seems to me that some symbols and ideas simply have universal significance.

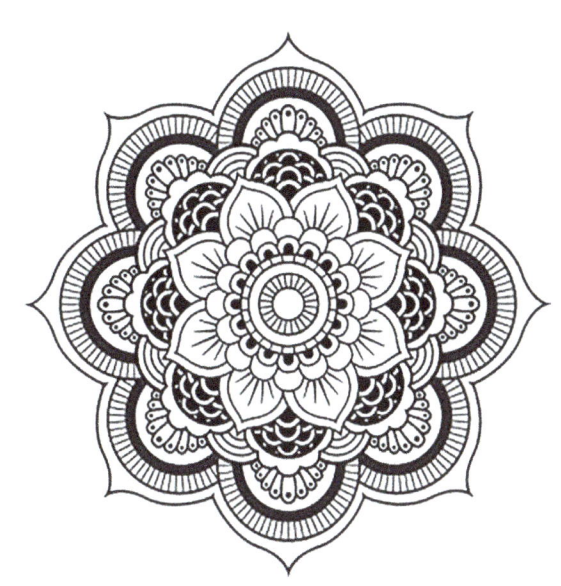

One of these is a circle. A circle represents wholeness, unity, and completeness. Mandalas are circular, geometric designs, but they are also so much more. From the website mandalaproject.org:

"The word "mandala" is from the classical Indian language of Sanskrit. Loosely translated to mean "circle," a mandala is far more than a simple shape. It represents wholeness, and can be seen as a model for the organizational structure of life itself--a cosmic diagram that reminds us of our relation to the infinite, the world that extends both beyond and within our bodies and minds."

Look around. Repeating geometric patterns are everywhere—in shells, plants, and architecture.

A mandala takes the circle to another level. These round, geometric designs are often used for meditation purposes. The simplified idea is that if you gaze at the mandala and allow your eyes to become slightly unfocused, taking in the whole design, the mind can become quiet. Another tool that is particularly popular in recent years, as coloring books have bloomed in popularity, is coloring a mandala outline. As you fill each space with color, it also quiets the mind.

This is what I have in mind for our next project. In the last chapter, I spoke about the importance of taking a retreat. Obviously, we can't go on retreat all of the time, but using a mandala as a meditation tool is a good practice. We will make our mandalas by layering something called "prefelt" and then cutting away areas for the design.

Wet Felted Mandala

What you need:

- 10"x10" wool prefelt in 3 colors
- 3"x3" wool prefelt in 3 colors
- plastic sheeting
- soap (*see note below)
- bubble wrap (at least 14"x30")
- hot water
- tub or basin
- very sharp scissors with a sharp, pointed tip!
- pins

A word about soap: There is a lot of information about what type of soap is best to use for wet felting. I have tried many different types and can tell you that there is no real difference in how they perform. I've used bar soap, liquid dish soap, olive oil soap, and even shampoo. They are all great for felting. The only real difference is how your hands will feel afterward. The benefit to using olive oil soap is that it makes your hands feel moisturized after felting instead of dried out, but you do pay more for it.

Making A Test Mandala

Step 1: Preparing

Look at your pieces of wool prefelt. I will be leading you through making a mandala of three layers, as pictured below. The basic thing to keep in mind is that your bottom color is the one that will show through all of your cuts.

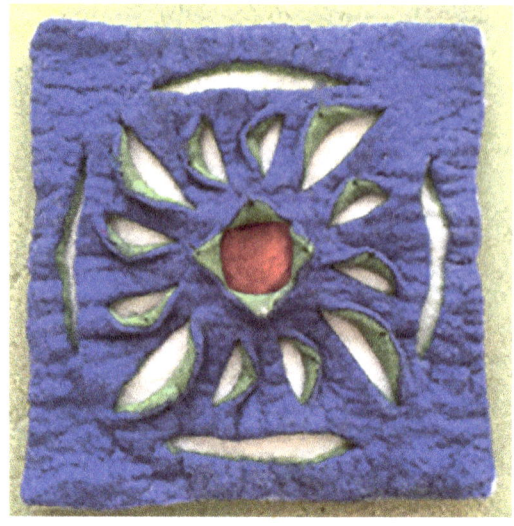

Whether you have experience with wet felting or not, I recommend making a small test mandala first in order to get acquainted with layering prefelt and using a resist.

Step 2: Layer your prefelt and resist

Cut three three-inch square pieces of prefelt in three different colors. Cut a piece of the plastic sheeting so that it is a half inch smaller on all sides than the prefelt (1). The plastic, as we are using it, is called a resist. The resist keeps one layer of wool from felting (connecting) to another layer when it's placed between them. We can use a resist strategically to enable us to make our designs. You will understand this better once we complete our test mandala. For now, just follow these instructions.

1
plastic smaller than prefelt

Stack the three small pieces of prefelt and the resist as follows (2):

1) Color A on top
2) Color B
3) Resist
4) Color C

2

Step 3: Wet out your prefelt

Lay your stack on a piece of bubble wrap, **bubble side UP**.

Wet down the stacked pieces. One way to do this (and there are many) without buying a fancy piece of equipment is to simply pour the water over your hand and onto the piece (3). The prefelt is delicate, so having the water pour directly from the tap onto it can separate and tear the pieces. Use your hand to break the stream of water.

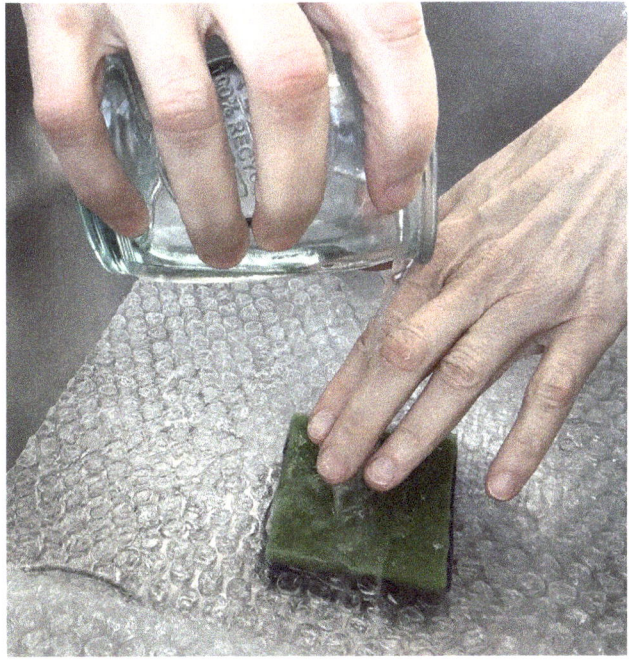

3

Place a small amount of soap on your hands (4), rub your hands together, and pat it onto your stack. Carefully flip it over and make sure the back is fully wet. Then pat some soap here, as well.

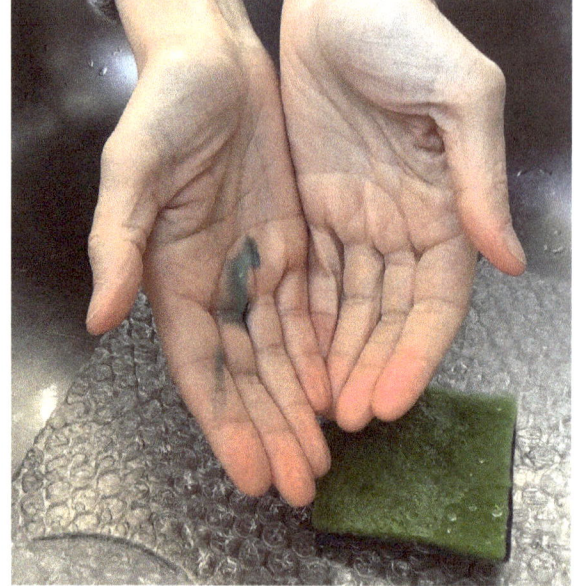

4

Step 4: Begin felting

With soap on your hands, lightly press and vibrate your hand for several minutes (5). These tiny motions will begin to bring the wool fibers together, starting the felting process. Turn the piece over and make sure everything is still in place. Then vibrate on this side, as well. If your little mandala gets cold, pour warm water onto your prefelt, just as you did in step three.

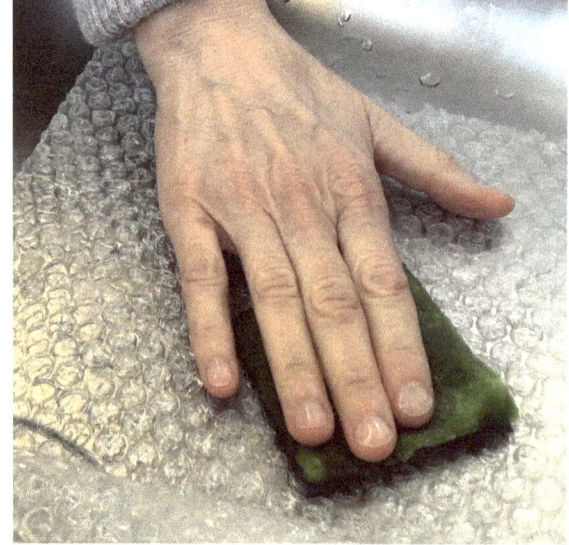

5

After several minutes on both sides, you will see that the prefelt is beginning to join together, becoming one piece of felt. This is what felting is all about! Now you can begin to rub it a little more vigorously.

Fold the other end of the bubble wrap over (on top of) your work (6) so that, as you start to rub the bubble wrap (7), your piece is being agitated on the top and bottom by the bubbles in the wrap (smooth side is out). It helps to have a little soap on your hands, which will help your hand slide over the wrap easily.

6

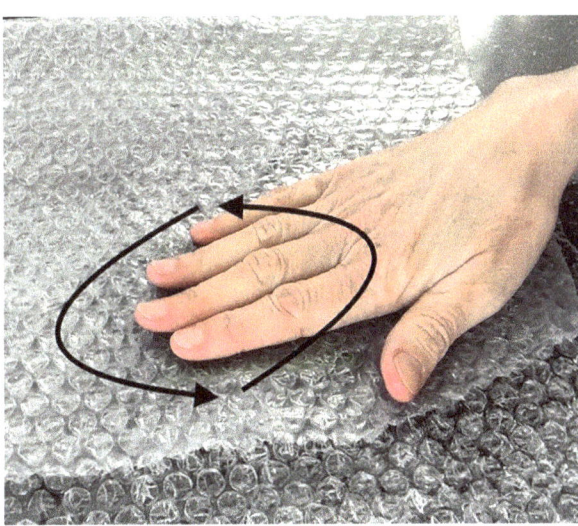

7

How do you know if your felt is fully felted? Try pulling it up with a pinch (8). If it's difficult to do, you are finished felting.

8

pinch test

If the wool is easy to pull up and feels like you could pull a bit of wool off, continue the prior methods of felting as well as the two rolling methods shown in the next two photos. The first shows rolling up your piece inside of the bubble wrap and rolling it back and forth (9). The next shows rolling the piece back and forth in your hands without the bubble wrap (10).

NOTE: Make sure you don't do this in any one direction too long, or your piece will shrink unevenly and may even stick to itself and turn into a big cigar! I unroll my piece frequently, turning it a quarter turn before rolling it back up to continue rolling/felting it.

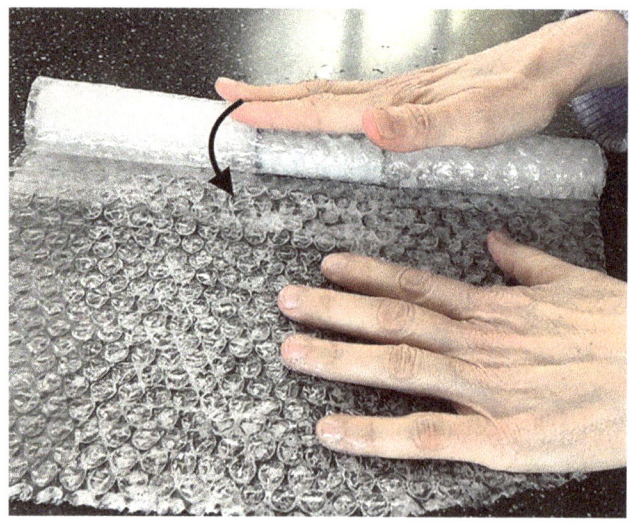

9

rolling piece back and forth in bubble wrap

10

rolling back and forth without wrap

Step 5: Cutting

After your piece is felted, lay it flat and pull it into shape. If your piece is particularly bumpy, iron it using the steam setting at medium temperature.

While your piece is still wet (or rewet it if it has dried), begin the cutting process. I like to use pins to help plan where my cuts will be. To make it look like a true mandala, the design is geometric and repetitive. BUT if that doesn't suit you, do what you want. It's all about creativity! I like to use straight pins to help me plan out my cuts and to actually guide me as I cut (11).

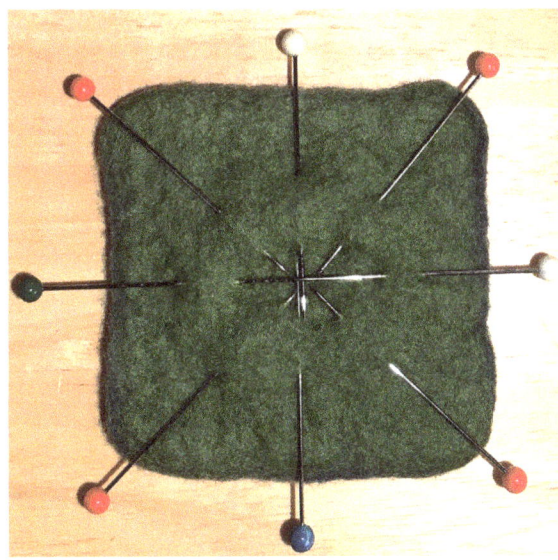

11

Using very sharp, pointed scissors, snip into your piece. Snip through the top two layers (they should be felted together as one layer now), but go no deeper (12). You should be able to see the plastic resist and the color of your bottom layer (13).

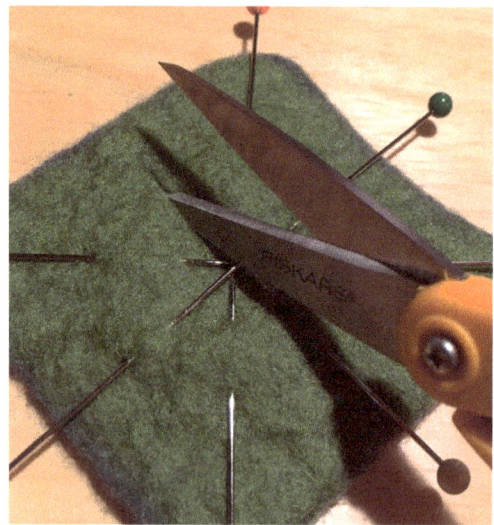

12

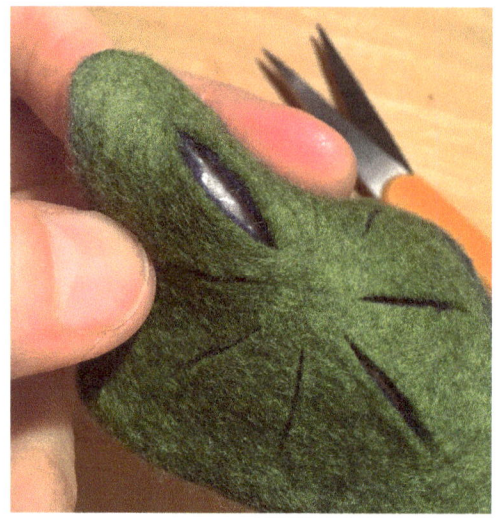

13

plastic resist and bottom layer of prefelt showing through cut

Step 6: Heal the edges

Once you have made the cuts in your piece, you'll notice how raw and sliced the edges look. WITHOUT REMOVING THE PLASTIC, wet your piece again and put a little soap on your hands. Roll and simply move your piece between your hands for a few minutes

(14 & 15), paying particular attention to the cuts by rubbing a soapy finger over them (16), and even between the top layer and the resist.

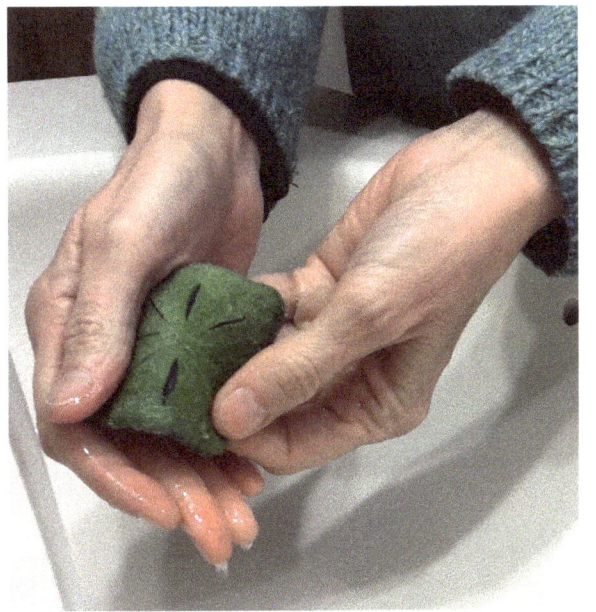

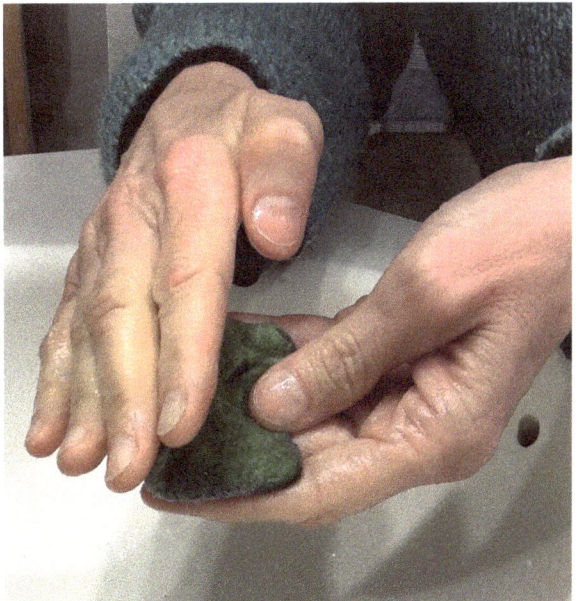

14

15

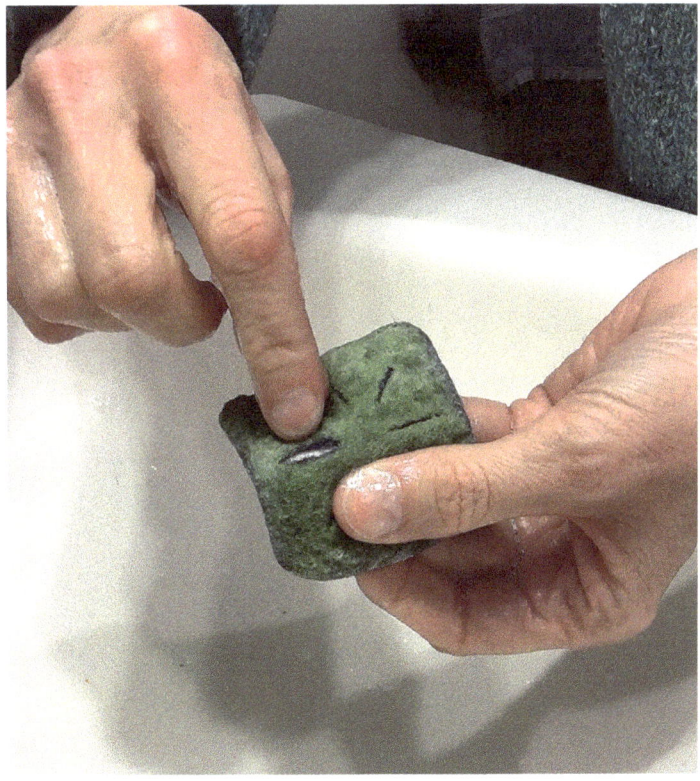

16

Step 7: Remove the resist

Once the edges no longer look freshly cut (in felting lingo, we say the edges are **healed**), rinse your felt and remove the plastic (17). The tip of your scissors may help you grab the resist so you can pull it out of one of your openings (18).

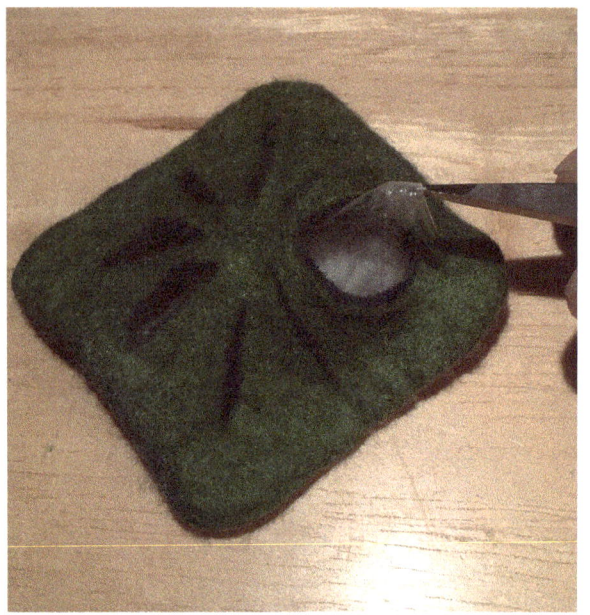 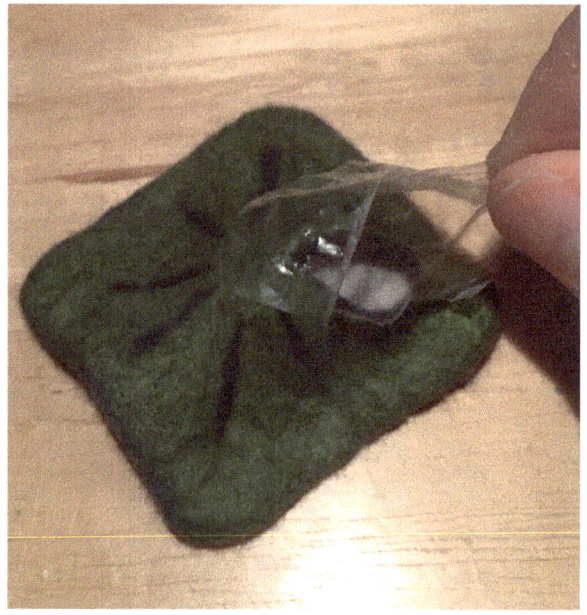

17 18

Step 8: Shape your mandala

Now it's time to tug, lift, and pull on the wool to make your design (19). For this sample, I simply pulled and lifted one side of each slit, leaving the other side flat to create my mini mandala.

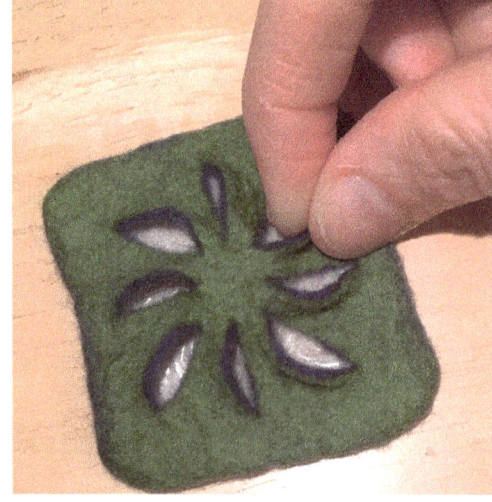

19

Making A Full-Size Mandala

Now that you've made the small test mandala, you're ready to make a larger, more complex mandala. You will be repeating all of the steps for the mini mandala but with larger prefelt sheets and plastic resist.

Step 9: Preparing

Using larger (ten-14") pieces of prefelt, decide how you wish to layer your wool. **Remember that the wool on the bottom is what will show through after you've made your cuts.** There is no right or wrong way to layer your wool.

The resist can be used in the same manner as it was in the test mandala to great effect, but you may want to try something new. How about cutting a ring and small circle from your plastic, creating a bullseye design? By doing this, you'll have two circular areas to work with: an inner circle and an outer ring. Just make sure there is enough of a wool border outside of the outer ring so that the wool layers can felt together into one piece.

Step 10: Wet out and begin felting

Felt your layers together using soap, hot water, bubble wrap, and motion (small vibrations to begin with, graduating to more aggressive motions).

Remember to use the pinch test to see if your wool is fully felted before you begin pinning and cutting your mandala.

See the bullseye in the photo below (20)? The layers of wool outside the ring and between the ring and inner circle have felted together, joining all of the layers. You can see how the green wool has mixed with the blue around the edges. Where the resist is, the wool was not able to felt together, so the blue is more vibrant.

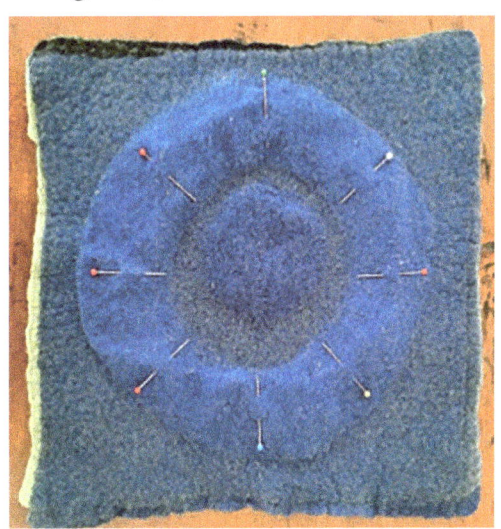

20

Step 11: Cutting

Plan out your design using pins or a fabric marker/pencil. In the photos below (21 & 22), you can see the pins I've put in place as well as the final cut design. For my example, I have cut my wool on each side of each pin, creating a little strip.

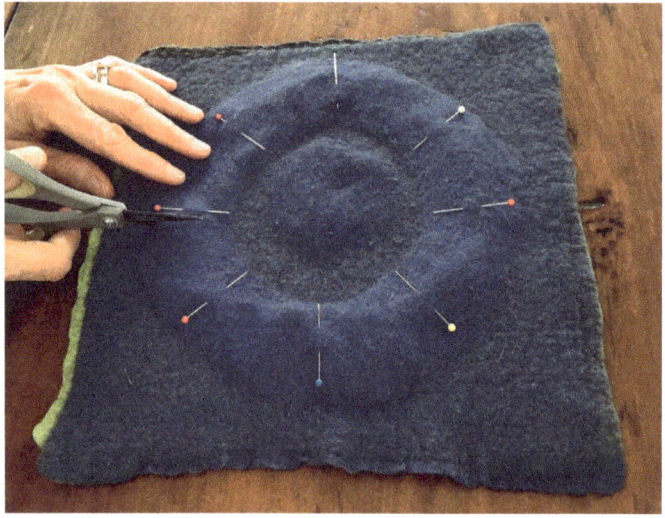

21

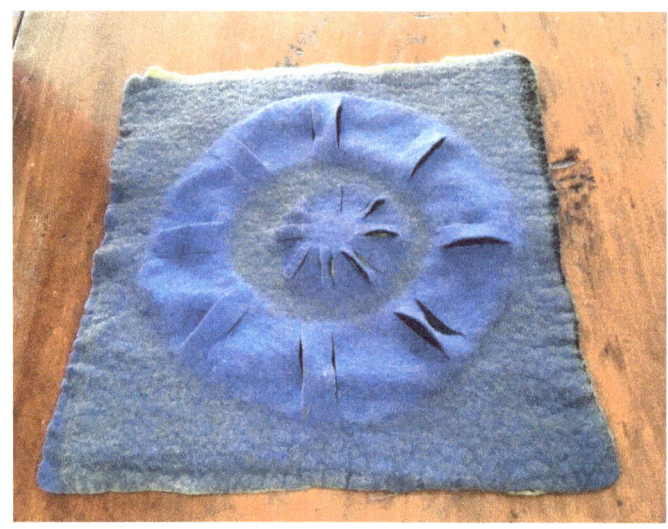

22

Step 12: Heal the edges

Leave the resist in place and re-felt your piece when you are done cutting, focusing on the edges of each opening. If you have cut on either side of the pins as I did, slide your fingers under the wool strip you created and VERY GENTLY rub the wool to heal the edges and felt the wool a bit more (23).

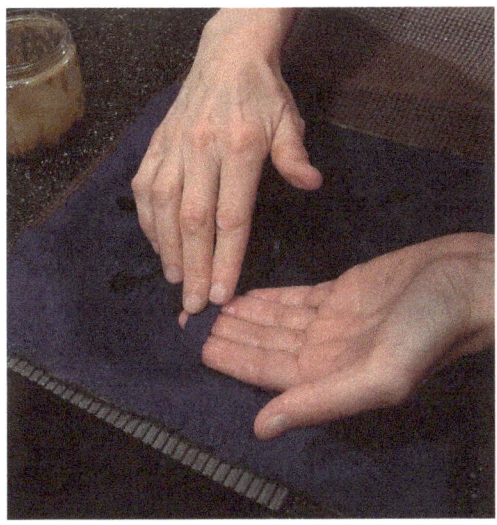

23

Step 13: Remove the resist

When you feel your felt is sufficiently felted, move the plastic resist. You may need to cut it in several pieces to get it out of your mandala.

Step 14: Shape your mandala

For my mandala, I twisted some of the wool strips so that they stand up (24). The inner part of my mandala is exactly like the mini mandala you created first, with the exception of cutting a small circle in the very center. Be creative and come up with your own techniques. And more than anything, enjoy the process!

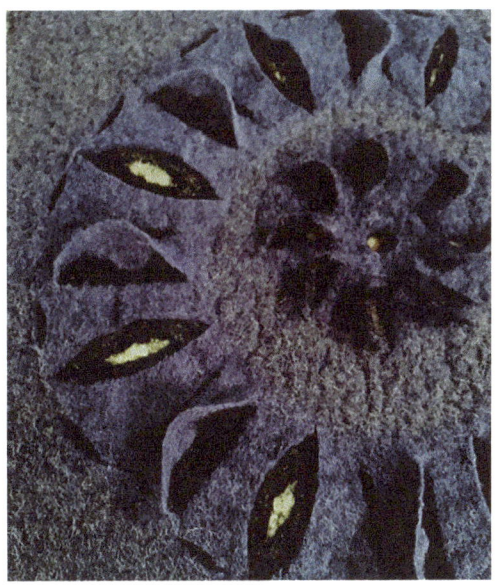

24

Chapter 9 — Ritual

I grew up in a home with a lot of turmoil and dysfunction. At some point in my 40s, I became aware of some patterns in my life that I was unhappy about and sought a therapist. It was an exhausting two-year process that dug up more than I expected.

I had an idea that I'd go sit on a couch, spill all of my "stuff" to the therapist, and be "cured" in relatively short order. I remember saying to my therapist within the first couple of weeks, "So, is this going to take days, weeks, or months?" Silly me.

One of the things I found helpful during this emotional (and often upsetting) time was having a little ritual of peace and calm. My intention for this time was to "unplug"—unplug from the issues with which I was wrestling; unplug from the stress that all of this change was placing on my marriage; and unplug from everything except a cup of coffee, a poem, or a passage in Scripture, or maybe even a journal and the lighting of a candle.

I'd have this little ritual when I was alone and my home was totally quiet. Sometimes I'd wake in the middle of the night and feel the call of this ritual. One night in particular, I recall lighting a candle and noticing the shadow my arm had made on the wall. I moved my arm more, and pretty soon my whole body. It wasn't anything pretty. Just movement. But at that moment, it was sacred movement, sacred space, and sacred time.

What was so important about this time? I think lighting the candle signified a setting apart of this time when I needed a break. I'd strike the match, light the candle, and take a deep breath, allowing my shoulders to first rise up to my ears and then (hopefully) come down to a place of rest.

I love the poems of Mary Oliver and the prayer poems from Ted Loder's *Guerrillas of Grace*. I love the Psalms and the Song of Solomon in the Bible. I love thoughtful quotes and soft Celtic music. Depending on my mood, any or all of these might be part of this ritual time. Sometimes I'd spend an hour and sometimes 15 minutes, but I always came away feeling refreshed.

As an artist with a flexible schedule, I realize I was fortunate to be able to carve out this time more easily than someone with a more structured job. However, I am convinced that if this speaks to your soul, you will find the time, as well.

What are the things that transport you to a calm place? A cup of tea? Poetry? A soft lap blanket on a comfy sofa?

Think for a moment and perhaps jot a few down. Then go over to the "Sacred Light" project to create something special to use in your ritual time.

Chapter 10

Take a moment:

My hope for you is that making this lantern will be a meditative and enjoyable process. How will you layer the wool colors? Will your embellishments symbolize something in your life? How will you use your lantern? Will it be the start of a meditation practice? Will it be on your dining room table as you call friends and family to join in a communal meal?

Sacred Light Lantern

Do you have a favorite color? Looking on sites like ETSY, you should be able to find wool and silk fibers in almost every color imaginable. You only need a small amount of both. See below for more information on what you need. The main thing to keep in mind is to use light-colored fibers that will allow the light from within your lantern to show through the lantern walls.

What you need:

- 1-2 oz. merino top roving in a light color
- 0.5-1.0 oz. tussah or mulberry silk fiber in white or
- a light complementary color (optional)
- soap (*see note below)
- hot water
- tub or basin
- 5-6" SMOOTH Styrofoam ball
- a bowl that will hold your Styrofoam ball
- 1 pair of nude-colored pantyhose
- sharp scissors with a pointed tip
- embellishments like wool neps and angelina (optional)

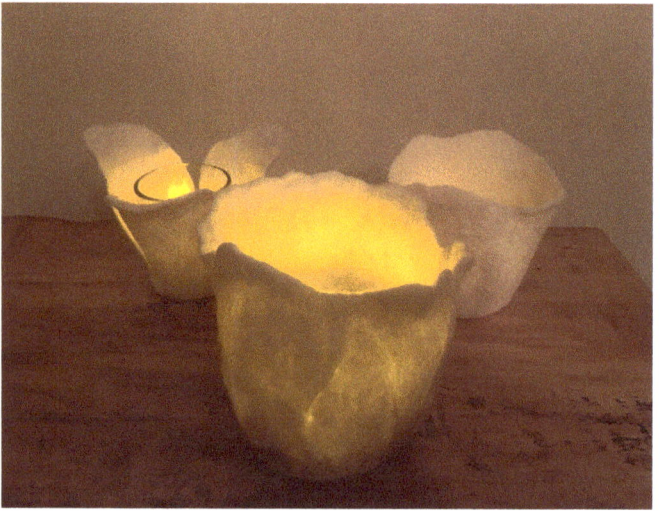

A word about soap: There is a lot of information about what type of soap is best to use for wet felting. I have tried many different types and can tell you that there is no real difference in how they perform. I've used bar soap, liquid dish soap, olive oil soap, and even shampoo. They are all great for felting. The only real difference is how your hands will feel afterward. The benefit to using olive oil soap is that it makes your hands feel moisturized after felting instead of dried out, but you do pay more for it.

Step 1: Laying out the wool

Pull off a three- to four-inch piece of your light-colored merino top roving. Hold one end of the roving loosely and pinch the other end tightly while pulling off very thin amounts of wool to lay out in a circle (1). If your Styrofoam ball is five to six inches in diameter, the circle of wool should be approximately 12" in diameter. It helps to work on a dark surface with the light-colored wool so you can easily see the thickness of your wool layers. Your wool should be laid out thin enough so that you can see the work surface through the wool, but there should be no holes where there is no wool.

1

Lay out a second thin layer of roving inside of and overlapping the first layer, using the same techniques that you used for the first layer (2). This laying-out technique is called shingling, as one layer overlaps the one before, just like roof shingles.

2

Lay out one more layer of wool inside of the last. This is a good time to add a light, contrasting color of wool to your layout (3). The center of the circle will be the bottom of your lantern.

3

If you've chosen to use silk or other embellishments, now is the time to add them to your lantern.

Pull off a three- to four-inch piece of silk and gently pull on both ends, allowing it to slip through your fingers and elongate (4). Your three- to four-inch piece of silk should

become six to seven inches long. This is called drafting. I drafted my silk to a length that will allow it to reach from the center of the circle out to the edge, then placed it on the wool. I repeated this all the way around the circle at about one-and-a-half-inch intervals.

4

Step 2: The ball and bowl

The size of the ball you use will determine the size of your lantern. Keep in mind that your felt will shrink considerably through this process. For example, the six-inch ball used in these instructions made a lantern that was approximately four inches tall and four inches in diameter.

The kind of Styrofoam ball that you use is very important. There are at least two types: those that have a rough surface and the ones that are smooth. **You need the smooth variety.** The rough ones will break down, leaving bits of Styrofoam embedded in your project.

As mentioned earlier, make sure the ball you use fits nicely into a rigid (ceramic/metal) bowl (5). The widest part of the ball needs to be below the rim of the bowl, as illustrated (6).

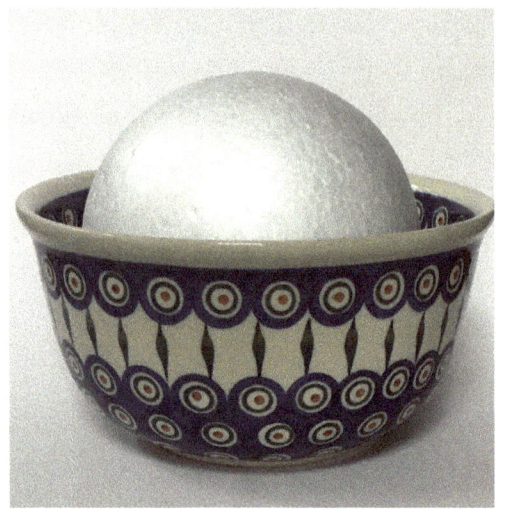 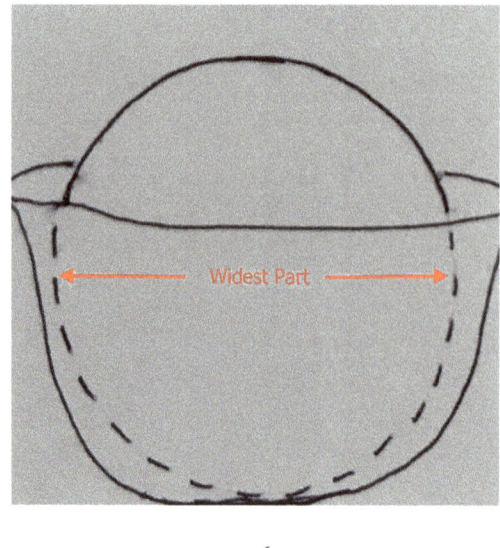

5 6

Step 3: The pantyhose

Make sure you are using nude-colored pantyhose. Why? Some of the darker or colored ones can leak dye, which will discolor the wool of the lantern that you've worked so hard to make.

Cut off the legs of the pantyhose, leaving a few inches of "leg" on the upper part of the pantyhose (7). You will be using the upper part of the pantyhose. Tie each of the leg openings into a knot (8). Your pantyhose will end up looking like photo 9.

NOTE: Save the leg pieces you cut off! They are excellent ties for bamboo rolling mats used in some wet felting projects.

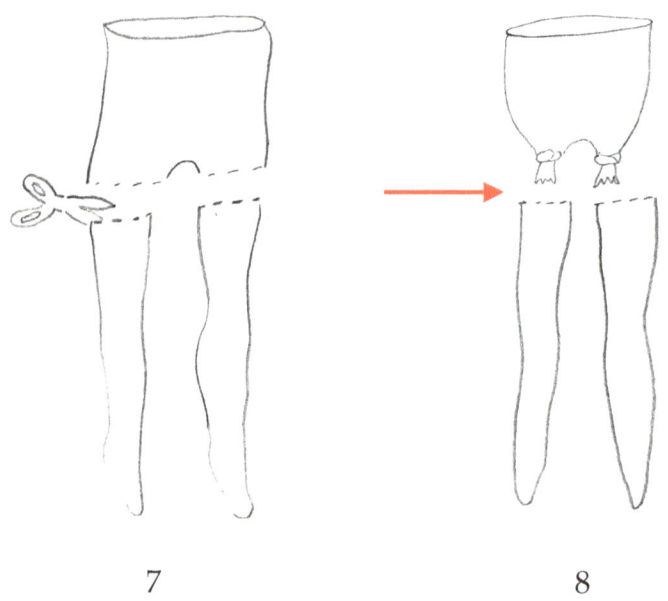

7 8

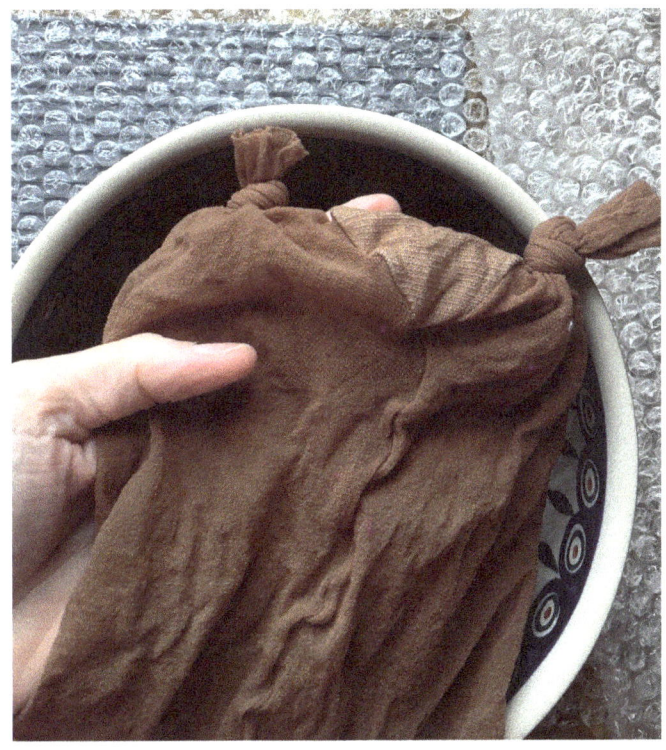

9

Stretch the pantyhose over the top of the bowl that fits your Styrofoam ball (10 & 11).

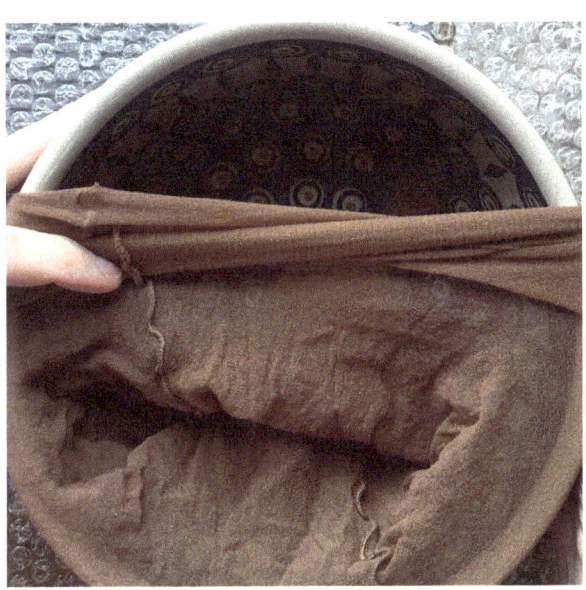

10

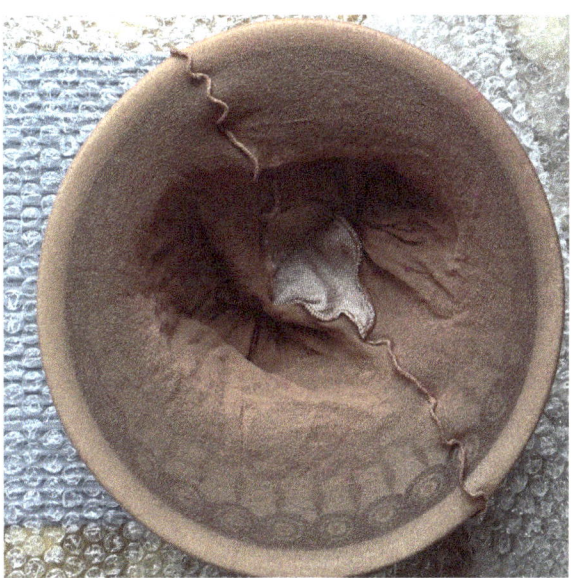

11

Next, place your ball into the middle of the wool you laid out previously (12). VERY carefully lift the wool up around the ball so that the ball is covered with the wool (13). If you lift the sides gently, they will stay together and not fall apart.

NOTE: If you're using a ball larger than five inches, you will want to make sure the diameter of your wool layout is sufficient to cover the ball. You may need an extra layer of wool around the perimeter.

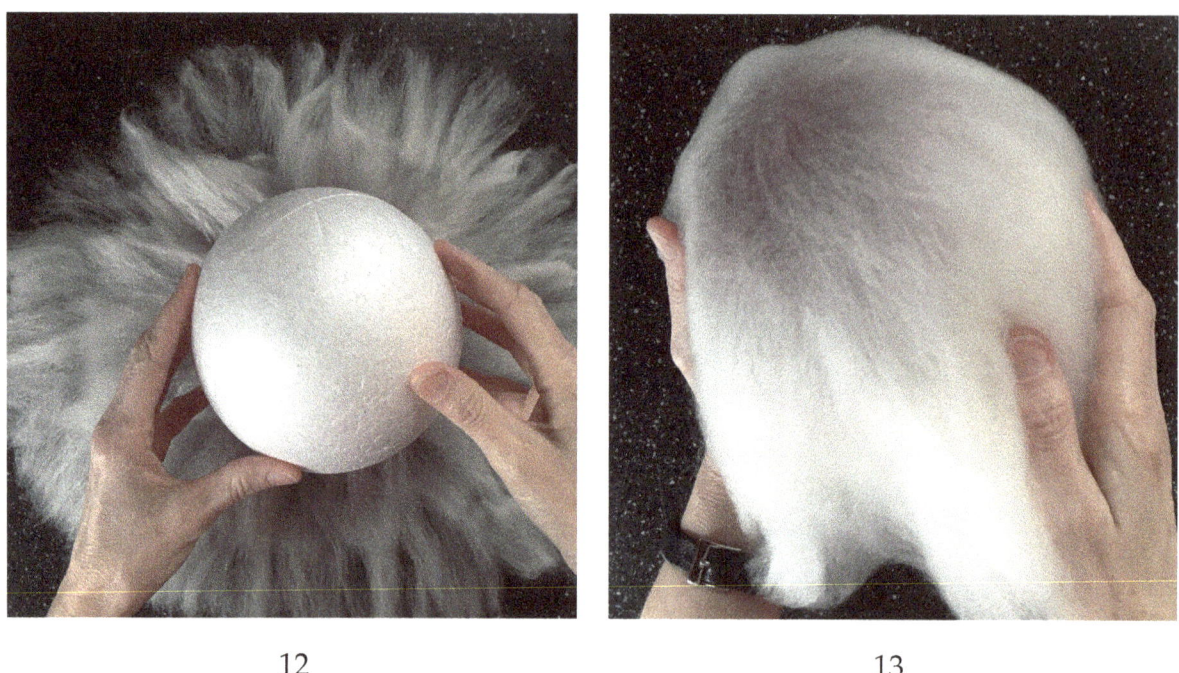

12

13

Carefully place your wool-covered ball into the pantyhose (14 & 15). You want to do this gently so as to not pull on the wool, causing a hole.

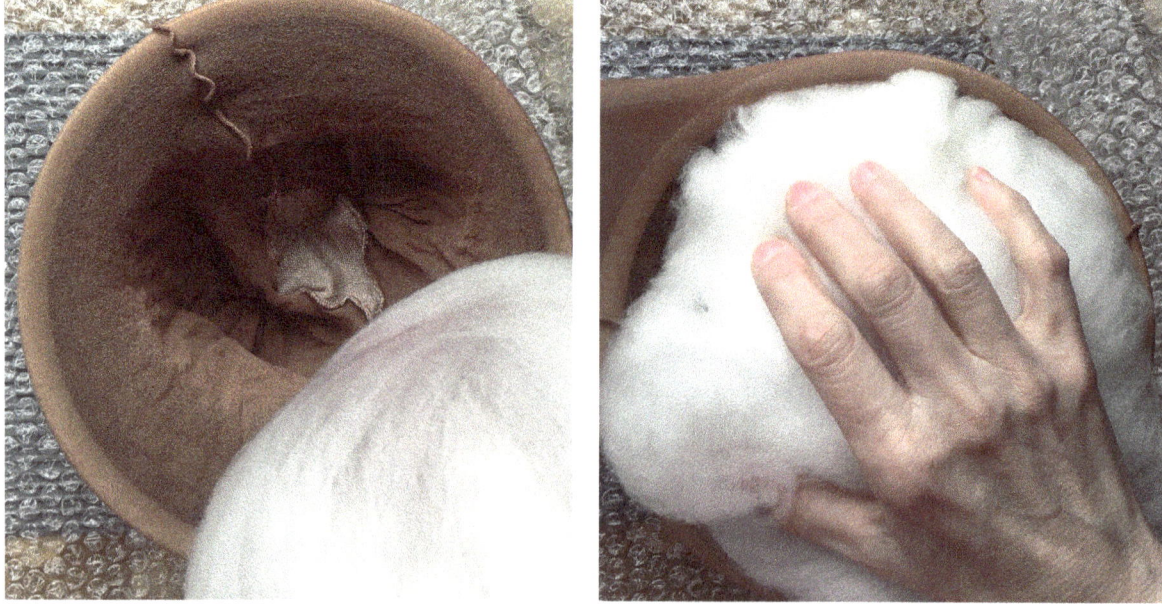

14

15

Holding the wool in place as much as possible, begin slipping the pantyhose off of the bowl so that the ball is covered by the pantyhose (16 & 17). Do this slowly, keeping a hand on the ball to keep it from popping out of the bowl.

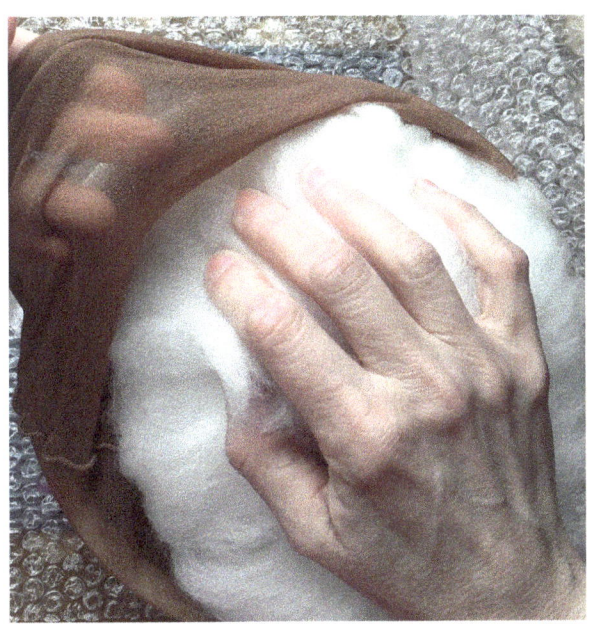

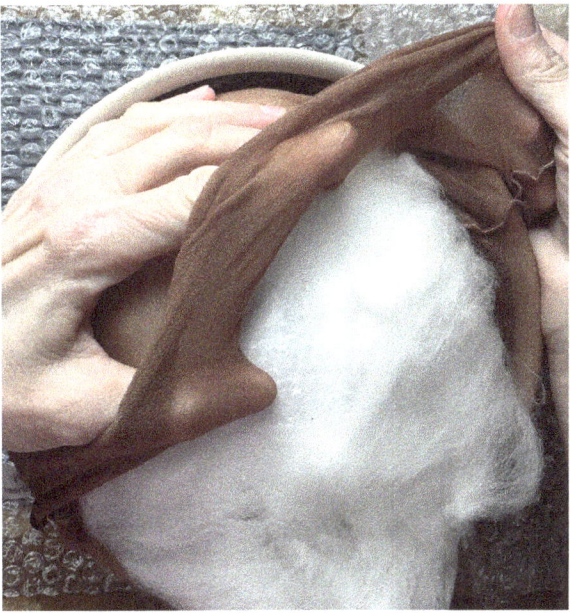

16 17

Once you have the ball inside the pantyhose bag, remove it from the bowl. Pinch the pantyhose snuggly against the ball (18) and knot the top so that it is sealed (19).

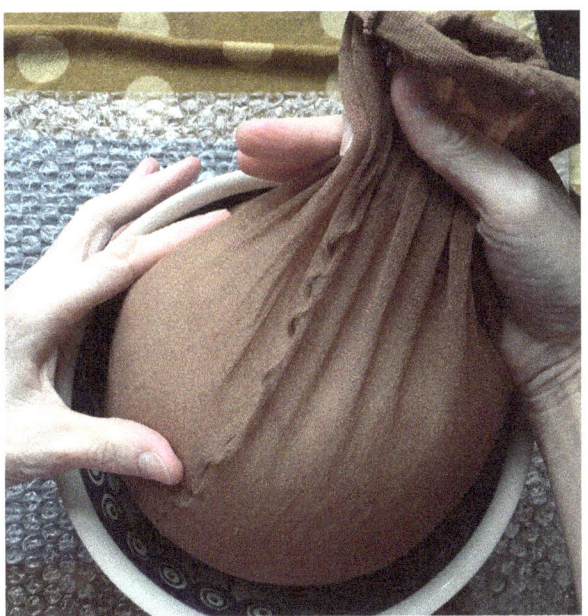

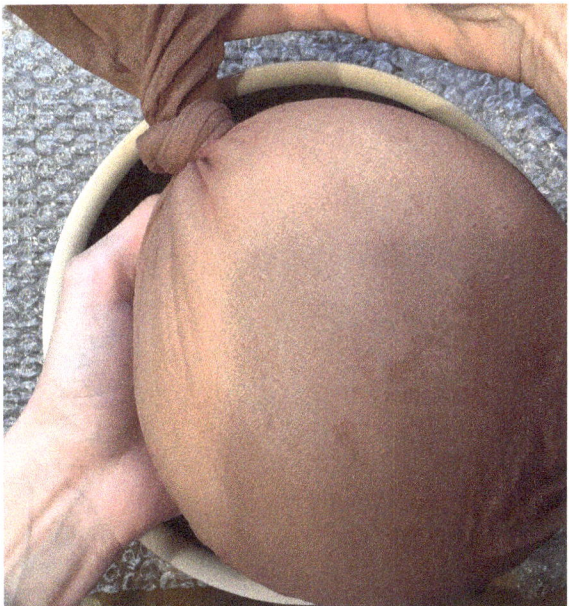

18 19

Step 4: Felting

Fill a basin with water that is as warm as your hands can manage. Add approximately a tablespoon of your chosen soap to the water as the basin is filling so the soap is mixed in. Immerse the ball into the water (20), pressing on the ball to get the air out, and fully wet all of the wool.

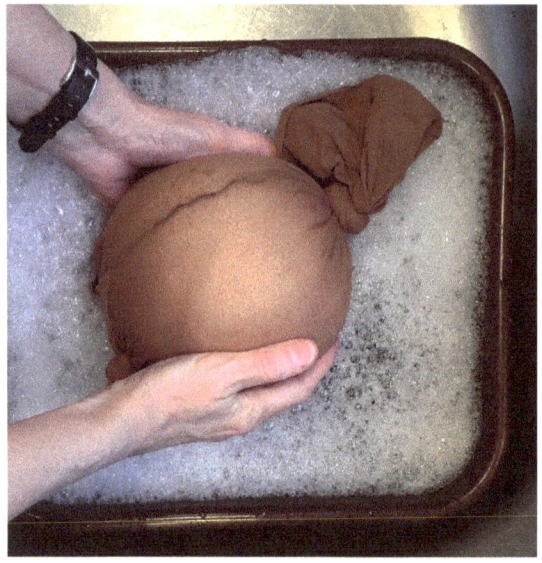

20

Add soap to your hands and very gently begin rolling (**not rubbing!**) the ball between your hands as if you are rolling a meatball (21). Do this for five minutes or so. You may not sense anything happening, but the fibers are beginning to join together and form a felt skin.

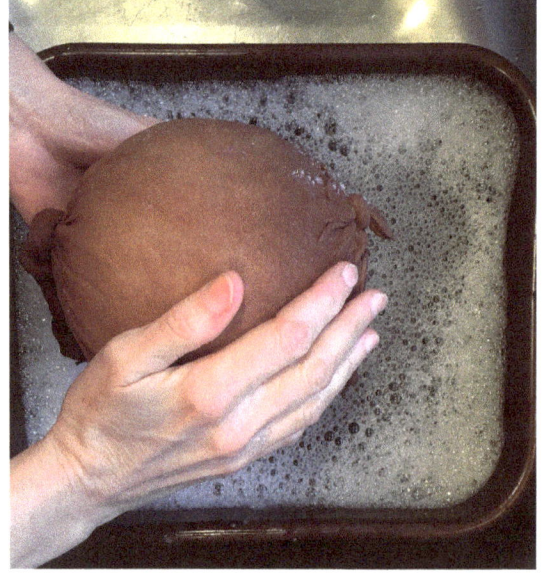

21

Now and then, add more water to the ball and more soap to your hands. If you see a lot of foam on your ball, you have too much soap. Photo 22 shows how much soap you want to see. No more, though. If you have too much soap, dribble water over the ball to wash some of it away. Too much soap and foam actually stops your wool from felting because it forms a barrier between the fibers, not allowing them to rub against each other.

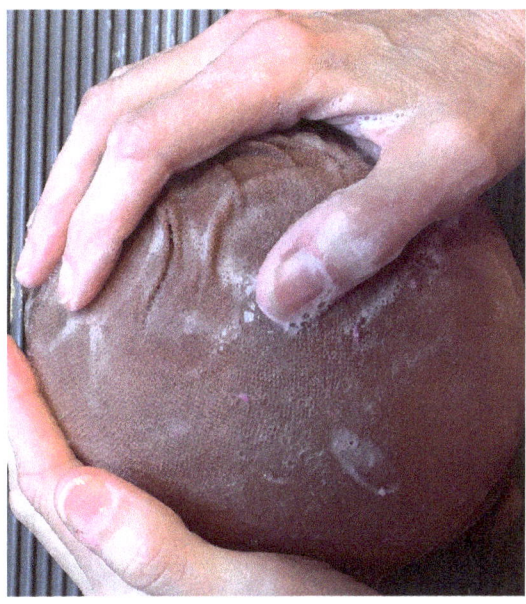

22

When you start to see the fibers migrate through the pantyhose (23), stop and untie the pantyhose. Place the ball back into the bowl you used previously and open up the pantyhose, pulling the top edge over the rim of the bowl.

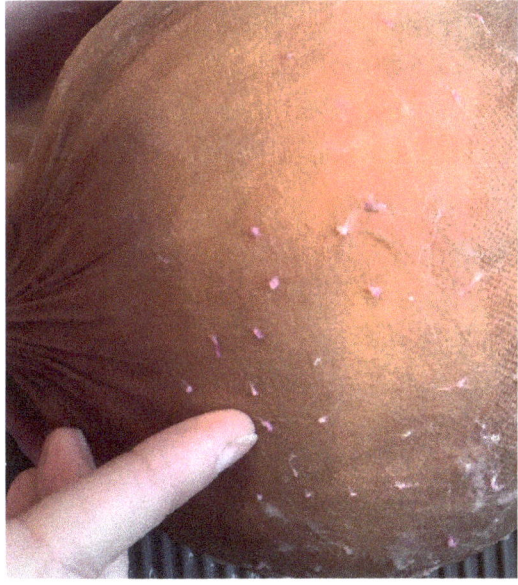

23

In photo 24, you can see how the wool fibers have attached themselves to the pantyhose. Very slowly and carefully pull the pantyhose away from the ball while keeping your hand on the wool and ball in order to keep from pulling the wool off of the ball. Do this all around the ball to free it from the pantyhose WITHOUT TAKING IT OUT OF THE PANTYHOSE (25).

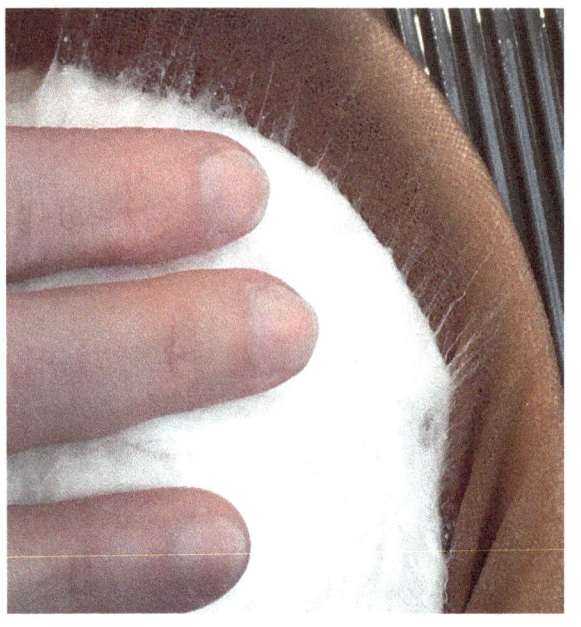
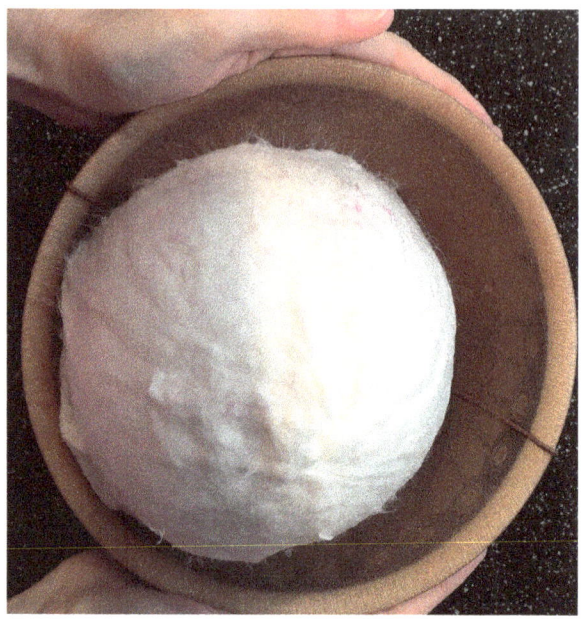

24
25

How do you know when you're done felting? Use the pinch test. Pinch the wool and gently try to pull the wool away from the ball (26).

26

When testing with the pinch test, if it feels like the wool could pull off easily, tie the pantyhose back up and continue rolling and rubbing the covered ball. After a few minutes, untie the pantyhose and check again. Don't forget to check that the wool fibers haven't adhered themselves to the pantyhose. Gently pull the ball and wool away from the pantyhose if they have.

Once you can feel a felted skin on the ball, remove your ball from the pantyhose. Continue to roll and rub it, adding soap to your hands and water to the ball as needed (27).

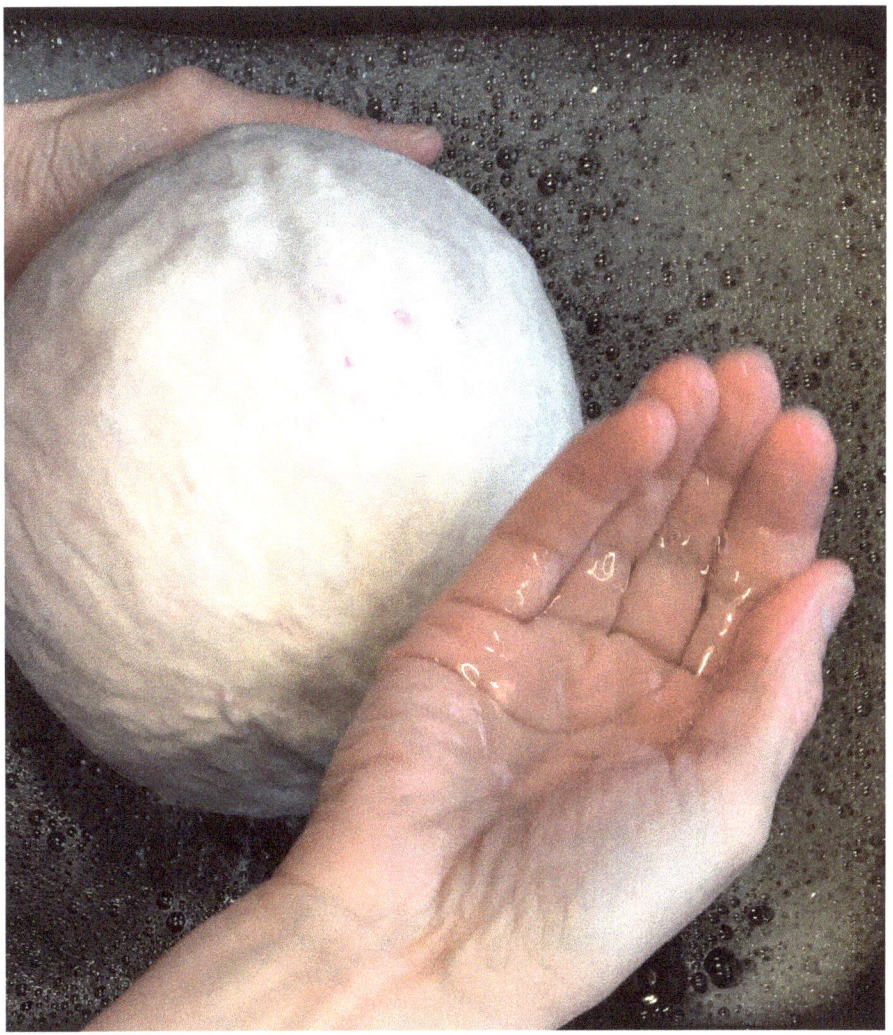

27

Wrinkles & Ridges: If you see wrinkles appearing on your ball (and you most likely will!), place your thumbs on either side of the wrinkle (28) and gently slide your thumbs apart (29) to stretch out the wrinkle. Do this all over the surface of the ball and do it FREQUENTLY so that your wrinkles don't become permanent ridges.

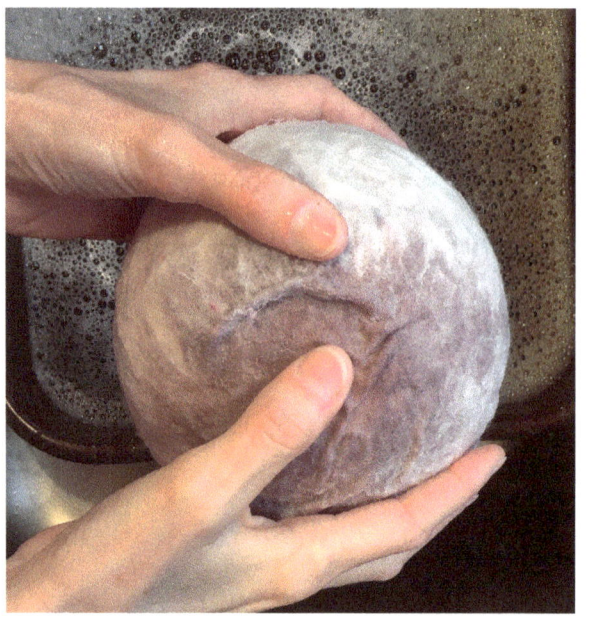 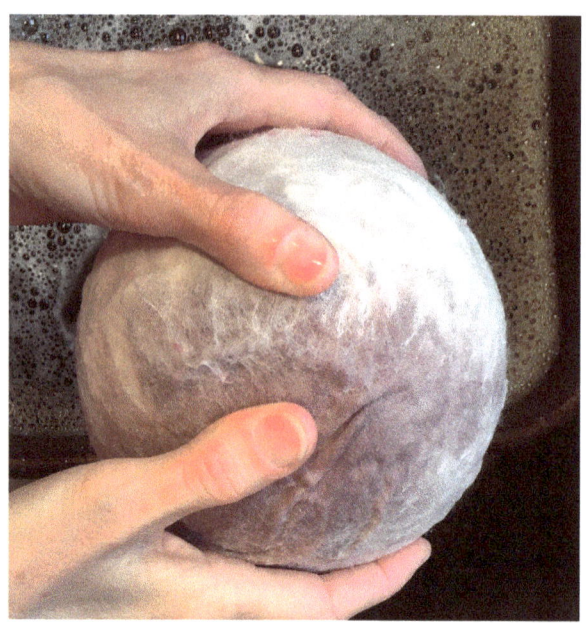

28　　　　　　　　　　　　　　　　　29

Continue rolling and rubbing until you sense no more shrinking of the wool and you can pass the pinch test. Once you reach this point, take your sharp scissors and cut a two- to three-inch diameter circle into the wool (30 & 31) on the ball. Remove the small circle, but don't take the wool off of the ball yet.

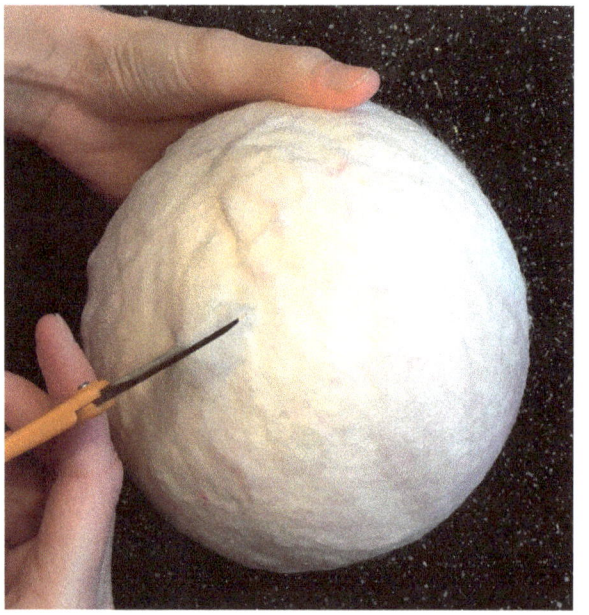 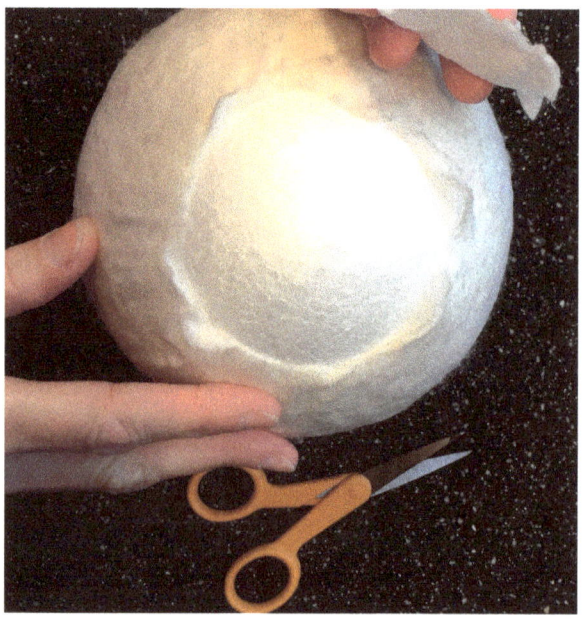

30　　　　　　　　　　　　　　　　　31

Before removing the wool from the ball, add a little soap to your hands, dip the ball in the water, and felt a little more by rolling and rubbing the ball (32). Concentrate on the

92

edges you just cut. This edge will be the upper edge of your lantern. By felting this edge, you are healing the edge, making it look more natural and organic, not freshly cut.

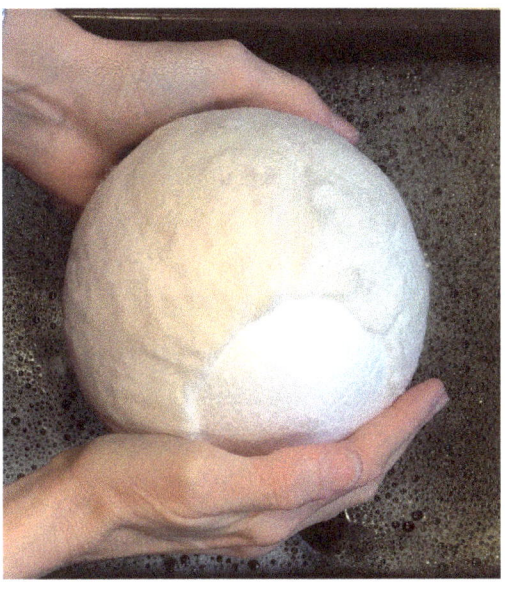

32

Step 5: Off the ball

You'll notice from the previous photos that the cut opening is not very large, but wool is very stretchy. Work your way around the ball, slowly pushing and shimmying the wool off of the ball as shown (33-35).

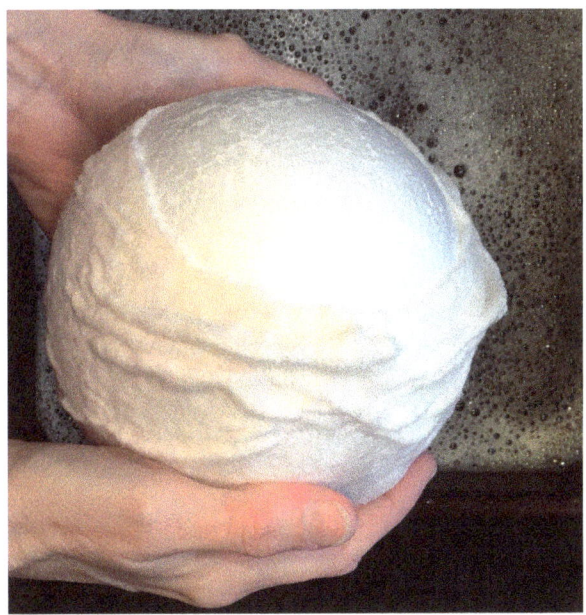 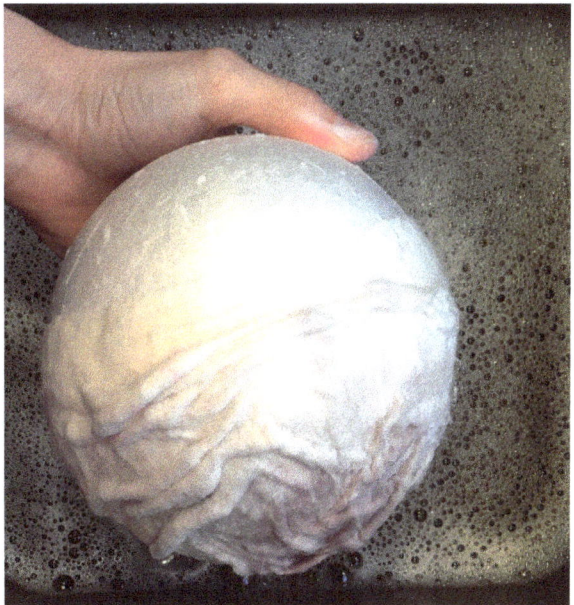

33 34

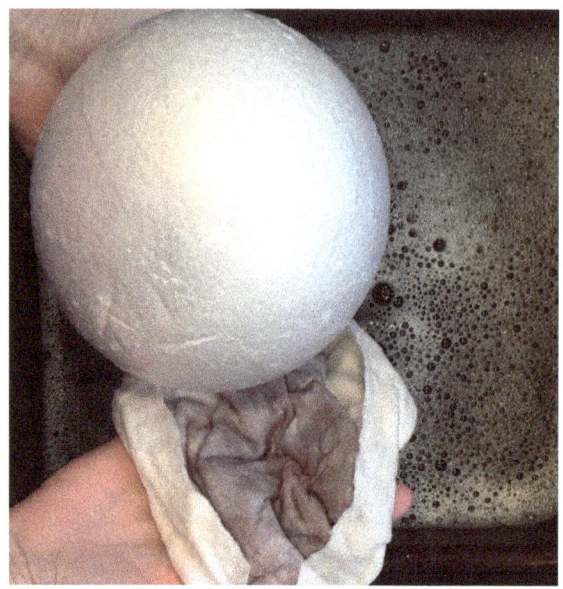

35

Make sure your water is still warm-hot and immerse the wool into the water with soap on your hands. Keep it moving by passing it from hand to hand, massaging it and rolling it. Keep checking that it isn't getting stuck to itself. Open it up, turn it inside out, and move it every which way (36-38). All of this movement makes the fibers rub against each other and integrate, becoming fully felted. Eventually, you won't see any more shrinking, and you are done with the felting process. Hold your piece next to the ball you used. Isn't it amazing how much it shrinks (39)?

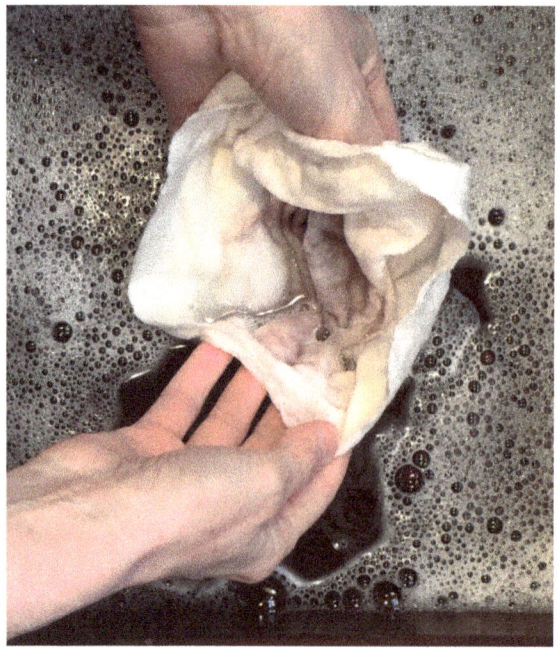

36

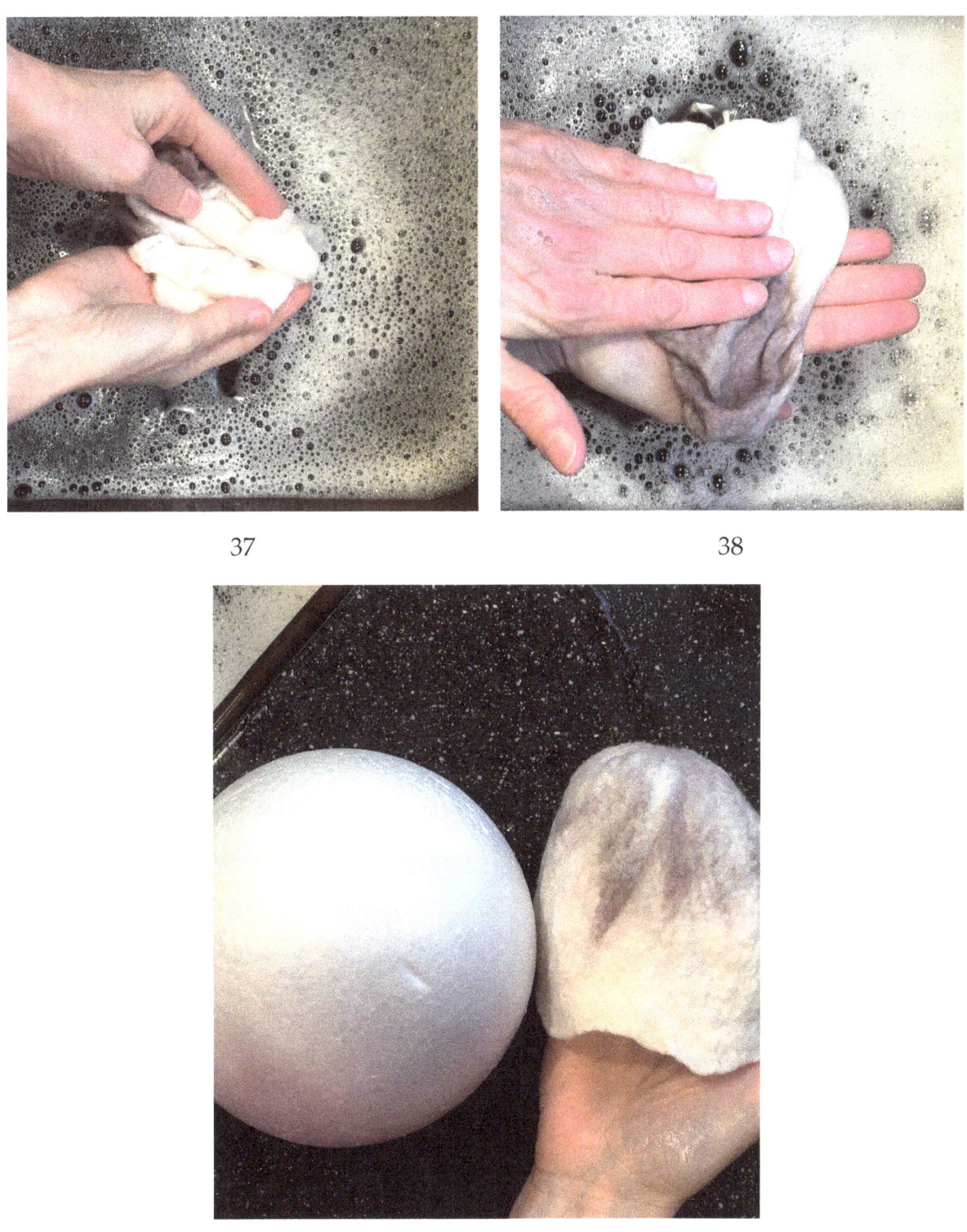

37

38

39

Step 6: Shaping

Tug and pull on your lantern until the top edge is how you would like (40). Maybe you like it ruffled. Maybe a totally smooth and straight top edge looks good to you.

40

Optional: Find a glass candleholder or a drinking glass that fits snuggly into your lantern to help you shape it (41). For this example, a stemless wine glass was the perfect size. If you have used a glass, leave it in place until your lantern is completely dry.

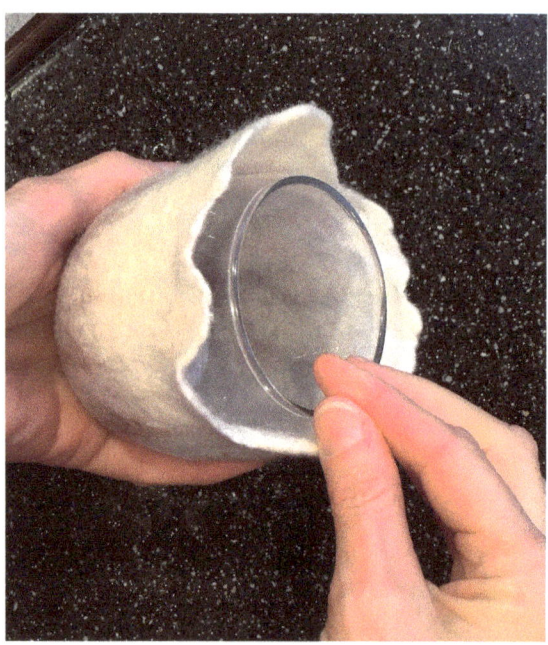

41

If you plan to use a real candle in your lantern, use a glass candle/votive holder inside of the wool lantern. You don't want a breeze to make all of your hard work go up in

flames. A better solution might be to use a battery-operated candle. That way, you don't need anything inside of your lantern to protect it.

How will you use your lantern? Will this be the start of a new meditative routine? Do you need to make more to have a grouping of them? My hope is that your lantern has deep meaning attached to it, facilitates healing if needed, and brings you peace.

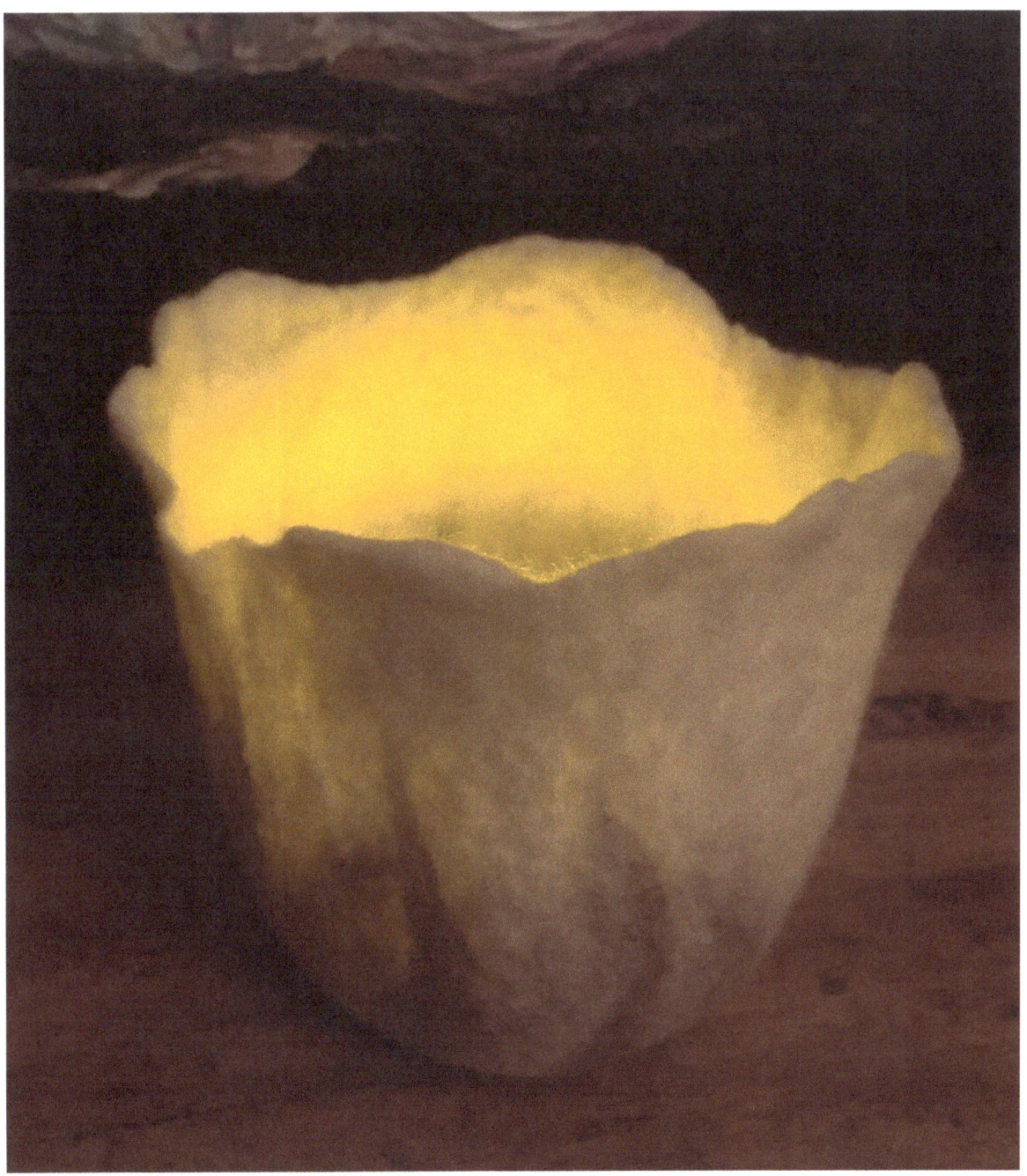

Healing

How do you know when you've sorted through the difficulties in your life and have come out on the other side? Is healing a tangible thing? I don't have the answer to those questions, but I have been fortunate enough to have a sort of measuring stick.

Quite a few years ago, I was asked to help bring an art component to a Christian retreat for mothers and daughters. *This is what I do*, I thought. *This is my "thing." It'll be easy.* I prepped several crafts for the group and arrived at the retreat.

As the event began that Friday night, I didn't know there was a little ritual the attendees did every year. Each mother-daughter couple would stand and introduce each other to the rest of the group. Then they each spoke of one thing they liked about each other. WHAM! I felt gut-punched and made an excuse to leave the room.

This retreat center has a beautiful hexagonal-shaped chapel with large windows all around, and a deck surrounds the building, with a bench seat all the way around the perimeter. I sat on the outdoor bench, and because it was dark outside, I could see everything that was going on inside. I silently wept.

I wept because I didn't have the kind of loving relationship with my mother that was obvious between most of these mother-daughter couples. I wept because my mother had died and there was no longer any hope of the relationship getting better. I wept because I couldn't remember one single, loving, gentle, sweet interaction with my mother. So much came bubbling up that I wasn't sure I even wanted to stay at the retreat, but I did, and fortunately, the rest of the event was enjoyable and not heart-wrenching.

Almost every year since, I have been the "art person" for this retreat. The second year I participated, I remember knowing the introductions were going to happen, so I found

my way to the benches outside the chapel. I watched from my outdoor seat, and at the end I realized I hadn't cried. Each year, I found the pain getting less and less, until I was actively taking part in the introductions. Though I don't have a daughter to stand with and introduce, I introduced myself and the art projects I had planned for the retreat.

I look back on that annual event and can measure the healing that took place every year. In large part, it's thanks to the amazing talents of a therapist I jokingly say is "worth her weight in gold," and leaning into my spiritual life, learning how deeply loved I am by God.

I suffered from a lot of neglect that comes from having a parent with an addiction. I will always feel some sadness that my mother couldn't and wouldn't be present in my life and love me the way I needed. But once I was willing to sit with the pain and work through it, things began to change.

Dealing with Feelings

There were people in my life who tried to talk me out of my feelings. They would say things like, "It wasn't that bad," or "It wasn't like physical abuse." I learned that in many ways, neglect is worse than physical abuse. The effects of not being seen—not registering enough on someone's radar to even warrant a slap or hit—is a whole different set of emotions, feelings, and scars to work through. I had to decide that my emotional scars were real and that even if the same set of circumstances wouldn't affect someone else, they did affect me.

I don't expect to ever be 100% through with my emotional "stuff." In fact, in church just a few weeks ago, I watched a little girl leap into her mother's arms, absolutely confident that she would be caught. She squealed with delight and tossed her head from side to side. She couldn't contain the joy she felt being in her mother's presence. I felt a shock of loss and was surprised that I felt pain watching this beautiful scene. I thought that part of my healing was complete. I don't know why that particular scene touched me as it did. It has been years since I reacted to something like that, and I'm not sure I'll ever know why. I think I'll always long for the feeling of my hair being stroked in the way I've seen other moms stroke their children's hair and how I've stroked my son's hair. Mother's Day will always feel a bit sad, though once I became a mother, the focus of the day shifted.

But as each year of the retreat has come and gone, I see the image of the onion from the beginning of this book. Each layer of pain is slowly being peeled away, but the mark—the

scar—that the skewer caused when it pierced the onion is ever present, though smaller and smaller.

On those gut-punched days, I often find comfort in the words of others. I love words that are put together skillfully and convey truth and inner longings. I have computer files and journals full of them. These are different than the poems and prayers I mentioned previously by writers like Mary Oliver or Ted Loder. These are more concise, usually no more than one to two sentences.

My love of quotes and my lack of having one place to look and read my favorites in got me thinking about having a small journal to collect them in—a felted one, of course. I'll show you how to wet felt a journal cover and some of the pages, adding embellishments and quotes, as well. So, collect some quotes (or whatever else has meaning to you) and make a little book to put them in.

Chapter 12

Take a moment:

Think about the things you can capture in a tiny book or journal that are welcome reminders of truths in your life. I'm talking about the things that have deep meaning, that make you see things differently or as you'd like to see them, and speak to your soul.

We'll be making a small book with a felted cover in this next project. I'm a quote lover, and I like the idea of having a small book where some of my favorite quotes can be collected. These are quotes that help me keep centered and not take on the weight of the world. An example of one of my favorites is:

> "If you think you've blown God's plan for your life, rest in this:
>
> You, my beautiful friend, are not that powerful!"

Not a quote lover? Think more broadly. Maybe your little book is for collecting images that speak deeply to your heart. Perhaps your little book stays blank and is given as a gift for someone else to fill. You may even want to incorporate previous techniques into this project, like making small wet felted flowers (same technique used to make the Sacred Light) that can be added to the cover. Whatever you decide, I hope you enjoy this project.

Tiny Book

What you need:

- 1-2 oz. merino top roving
- embellishments of your choosing
- soap (*see note below)
- hot water
- tub or basin
- bubble wrap (at least a few inches larger than your cover)

***A word about soap:** There is a lot of information about what type of soap is best to use for wet felting. I have tried many different types and can tell you that there is no real difference in how they perform. I've used bar soap, liquid dish soap, olive oil soap, and even shampoo. They are all great for felting. The only real difference is how your hands

will feel afterward. The benefit to using olive oil soap is that it makes your hands feel moisturized after felting instead of dried out, but you do pay more for it.

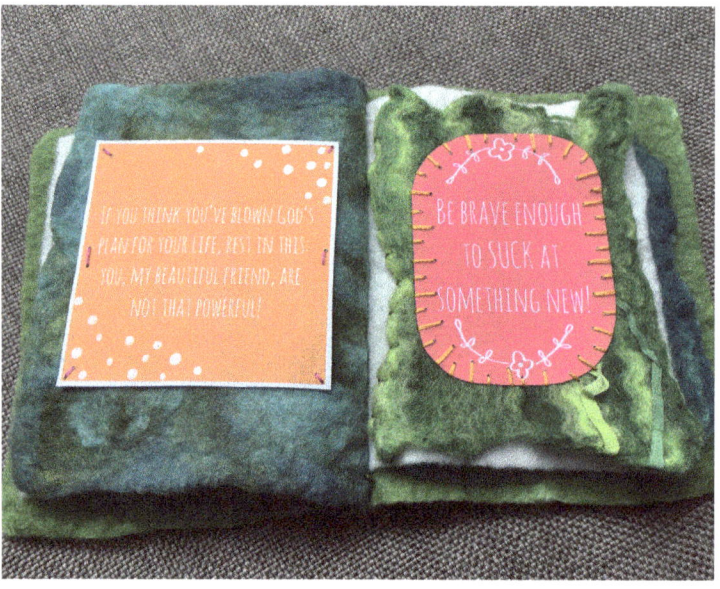

Step 1: Laying out the wool

For a book that will be approximately four to five inches, pull off a length of about eight inches of your main color merino top roving (1). Separate this piece into two or three pieces by pulling it apart lengthwise, as shown in photo 2.

1

2

Work on your bubble wrap, with the bubble sides up. Hold one end of the roving loosely and pinch the other end tightly while pulling off very thin amounts of wool.

Lay these in a line (3). Notice how thin and wispy the wool is? There is no need to use huge amounts of wool, especially since we'll be layering and overlapping this layer with another layer or two (or three…).

3

Lay out a second row of roving, using the same technique that you used for the first layer (4). This layer overlaps the first row. I usually cover about half of the preceding row with the next row. If you made the Sacred Light project, you already know what this technique is called: "shingling." Can you guess why?

4

Lay out another row or two of wool, overlapping the row before. The length of your rows and how many rows you lay out is up to you. Keep in mind that felted wool shrinks between 30-50% from its original size. You may wish to measure your piece before and after it's felted to see how much your piece has shrunk (5).

5

Now, cover the entire first layer by shingling on more wool perpendicular to the first layer (6). This wool may be the same color as the first layer, or it may not. Experiment and have fun!

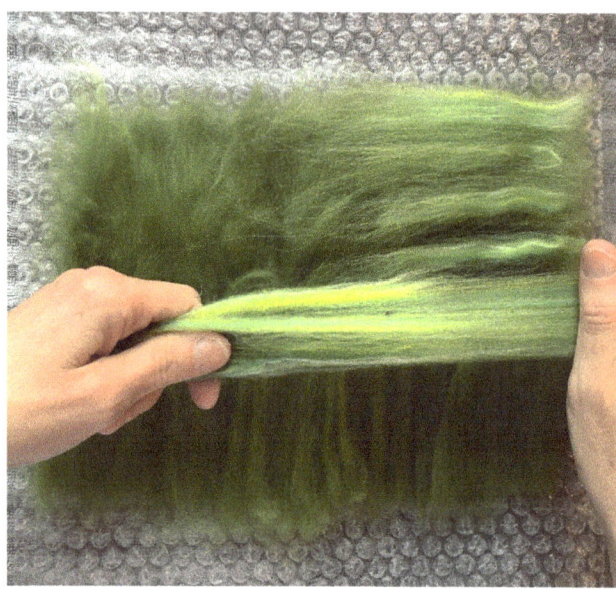

6

Embellish your journal cover in any way you wish. I used various colors of merino top to make stripes on my cover (7). You may wish to add a shimmer to your surface by using angelina, silk, or bits of wool yarn. Be creative.

*See note below about adding thick embellishments and non-wool embellishments to your work.

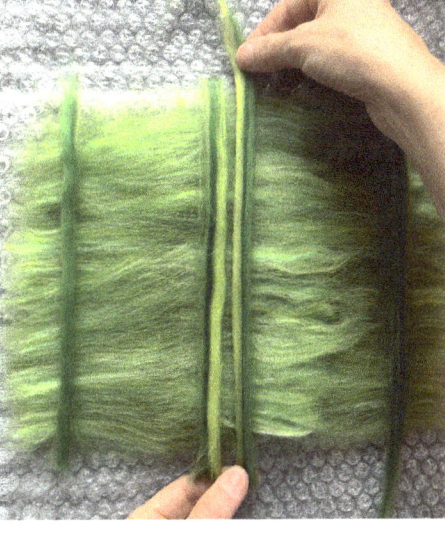

7

Step 2: Wetting out and adding embellishments

Wet out your piece with warm-hot water using a ball brause (8) or by pouring the water over the top of one of your hands so that it makes the water hit the wool surface more gently. Then soap up your hands and gently press them onto the wool surface (9).

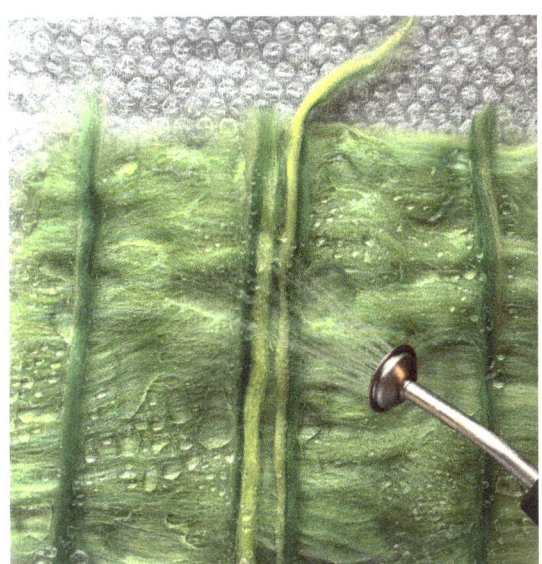 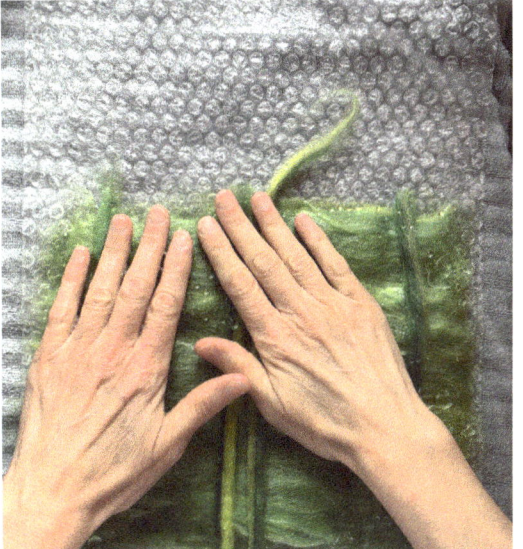

8 9

Cover your piece with bubble wrap (bubbles facing the wool), press the surface to squeeze out the air between the wool fibers, and begin the felting process (10 & 11).

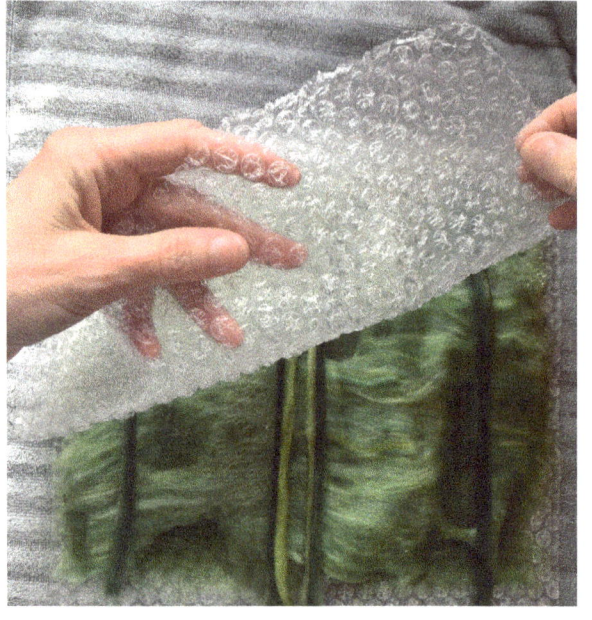
10

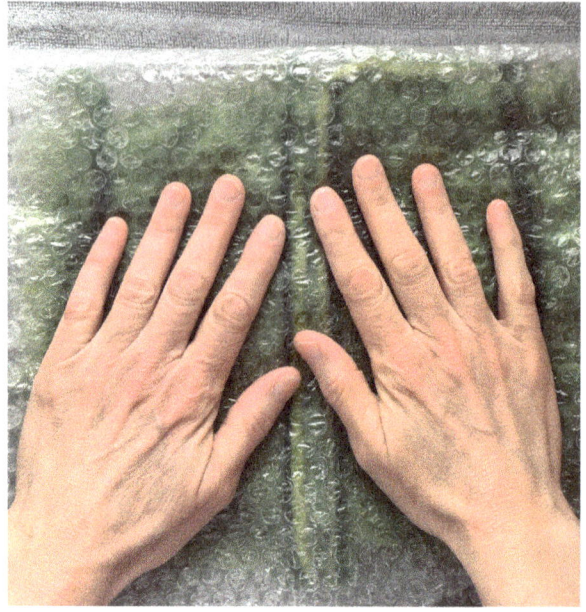
11

Uncover your piece. This is your last chance to add more embellishments or to straighten the sides of the piece. I fold the bubble wrap over the sides of my work, as shown in photo 12, to help me get nice, straight edges. I placed wool neps onto my cover at this point in order to add a bit more texture (13). If needed, trim any longer, stray fibers using scissors.

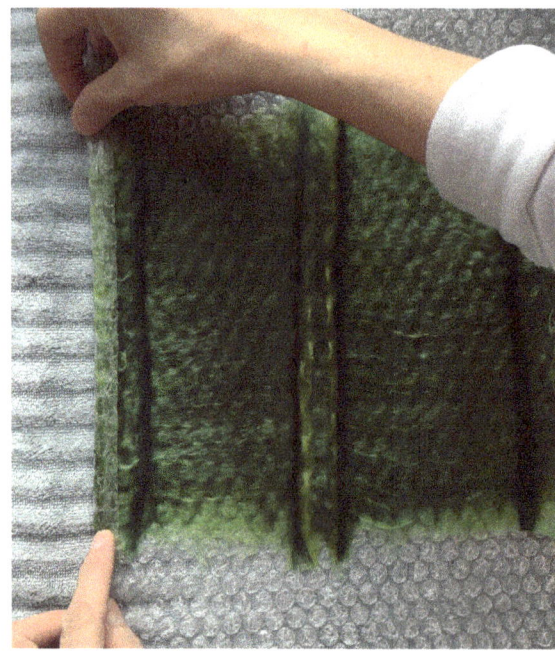
12

Important: Working with bulky embellishments and non-wool fibers can be tricky. Bulky embellishments can be rubbed right off of your piece, and non-wool fibers lack the microscopic characteristics to integrate with wool. Both need to be "encouraged" to attach to wool. You accomplish this by laying the wispiest amount of your main color wool over the embellishments so that they become sandwiched between the bottom layers of wool and this wispy top layer (14 & 15). If you keep your wispy layer as fine as possible, it will not show once your work is felted.

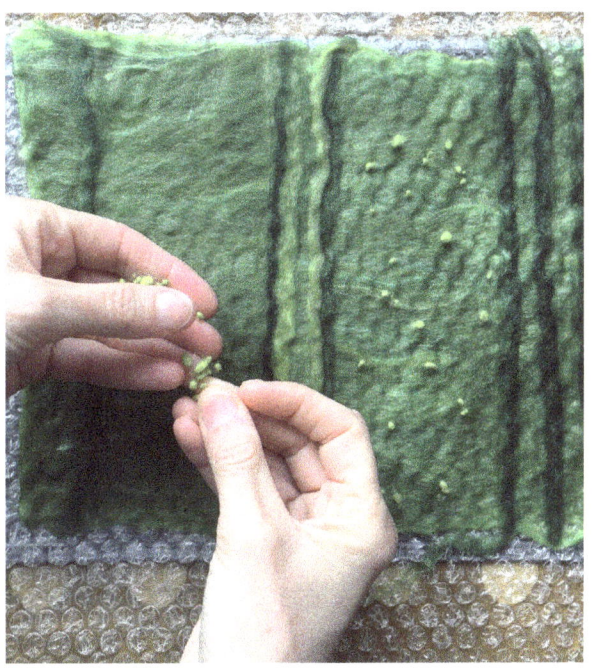

13

14

15

Step 3: Felting

Replace the top layer of bubble wrap and gently rub the surface. Putting a little soap on your hands will help your hands slide over the plastic a bit easier (16 & 17).

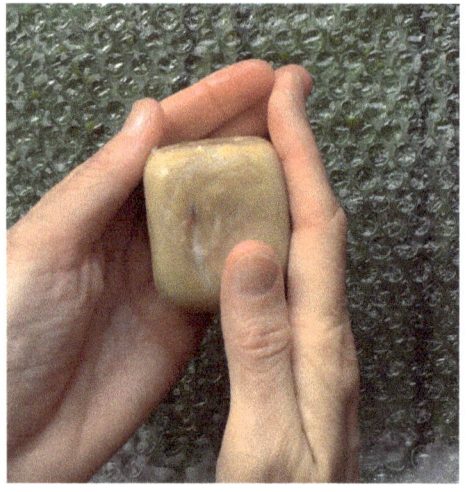

16 17

Check your piece from time to time to see if the felting process is beginning to happen. Add more warm water and soap occasionally, as well.

Once you see the felting process begin, you can roll the bubble wrap up with your work inside (18). Now and then, open the bubble wrap, turn it a quarter of a turn, rewet it, and cover it up again.

Continue felting and checking your work, turning your work a quarter of a turn each time you check it. The turning helps the work to shrink evenly.

18

As you see your work become more and more felted, as well as seeing it shrink, you can eventually remove the bubble wrap and roll your work without it. Roll it in every direction, even diagonally. The agitation, along with additional warm water and a bit of soap, will keep the process going until it is done.

If you wish, pull out a measuring stick and see how much shrinkage you obtained (19). Fold your cover where the spine of your little journal will be and set your cover aside to dry.

19

NOTE: Don't be afraid to pull and tug on your journal cover once it is fully felted. Often, it helps to pull it into shape to get straight sides and nice corners. Wool is very durable and can take the manhandling.

Step 4: Adding pages

Repeat steps one-18 to make additional pages for your journal. These pages can serve as dividers separating different sections of your little book, or you can attach paper right to them by stitching the paper to the wool (as I'm doing below). If quotes aren't something you find meaningful, turn your little book into something else. Maybe a needle case for emergency repairs would be something you or a loved one might find useful. If you enjoy stitchery, maybe doing fancy embroidery on the pages would make it personal for you.

For my book, I printed out some of the quotes that I find especially meaningful onto cardstock. Then I attached them to my wool pages. If you are planning on doing something like my book, you'll need:

- Thread or embroidery floss
- Sharp needle
- Quotes printed on heavy cardstock

Step 5: Planning printed quotes

Cut out your quotes into sizes and shapes that please you. A little planning can make putting your book together easier and will give your book a better look at the end. When putting quotes on both sides of a page, I like one to be larger than the other. I start by sewing the smaller piece of paper to the page first. That way, any stitches that might have shown on the reverse side will be covered when I add my larger piece of paper (20).

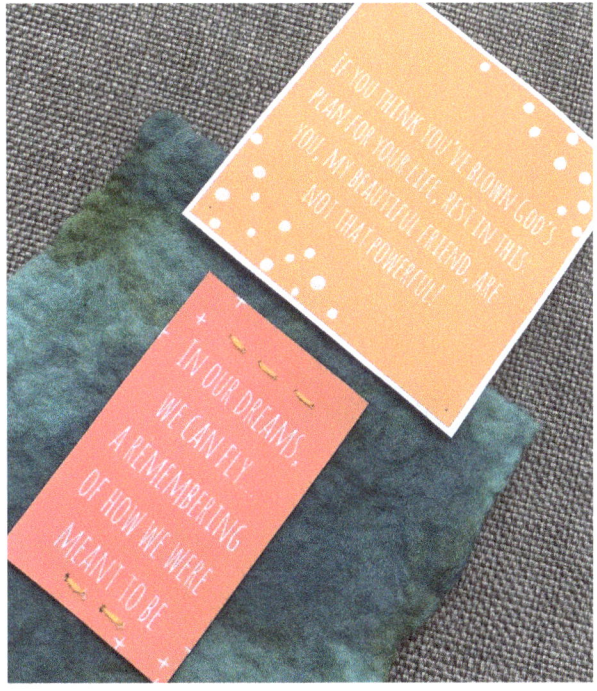

20

Step 6: Preparing printed quotes

Use your needle to prepunch the holes needed for sewing the paper to the wool page (21). I've found that if I don't prepunch the holes, I end up bending my cardstock too much as I'm pushing the needle through. Then sew your paper to the page using these holes (22).

21

22

Step 7: Stitching

Look closely at photo 23, and you'll see several stitches showing from attaching the smaller piece of paper. This larger paper will cover those stitches. By doing this, I only need to be careful to hide my stitches while sewing the second quote (24).

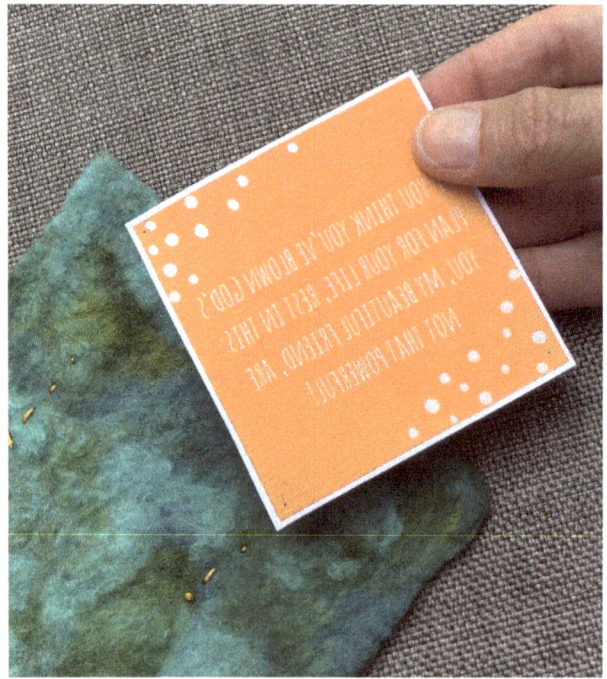

23

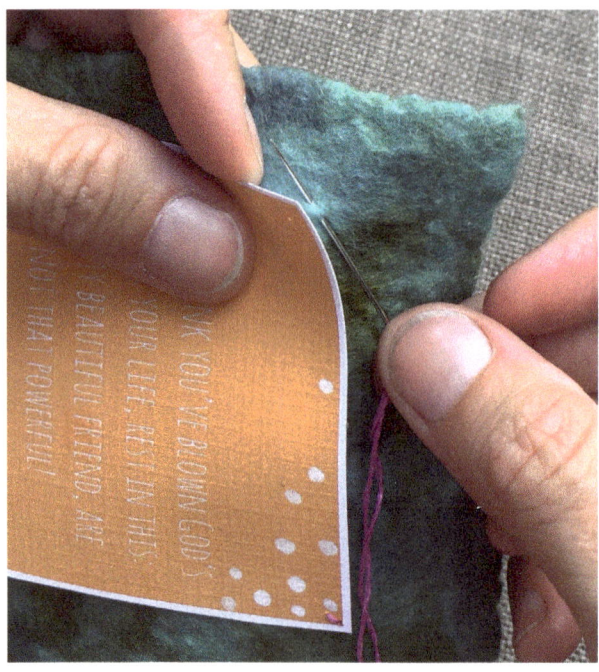

24

You may want a variety of stitch styles (25), and you may even want some of them to show on the back side (26).

25 26

Step 8: Assembling your book

Lastly, line up your pages and sew them to the cover. I did a simple running stitch (27), but you may want to do something fancier or even use a sewing machine to bind them all together.

27

I like my pages to be uneven and undulating (28 & 29). If you don't, you can always cut them on the "binding" edge to get them to line up.

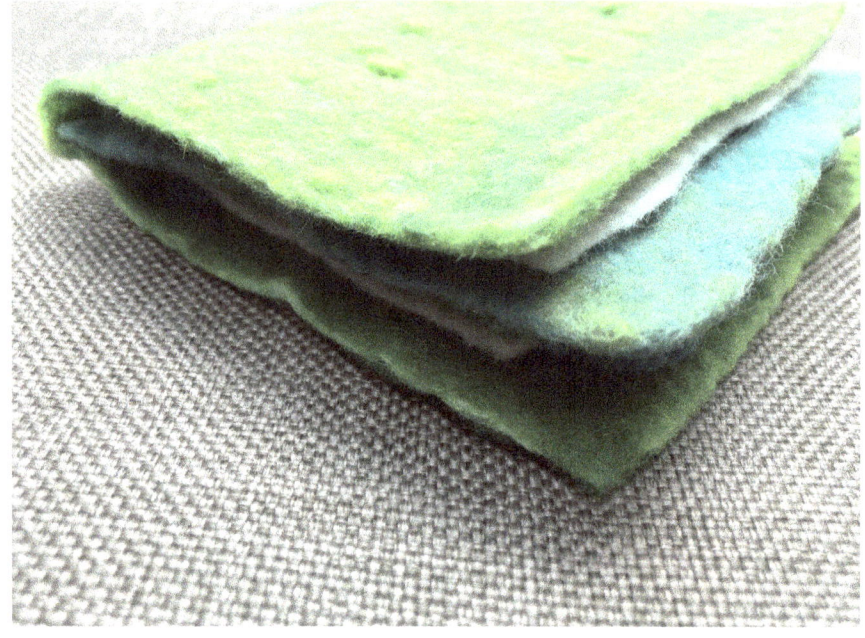

28

As you can tell, this project was rather free flowing. My hope was that you would learn skills in wet felting a flat piece of felt. Once you've mastered the technique, your felt can be turned into whatever you'd like it to be. Maybe it isn't even a book at all. Perhaps you've decided to make a book cover or something else entirely. Run with it!

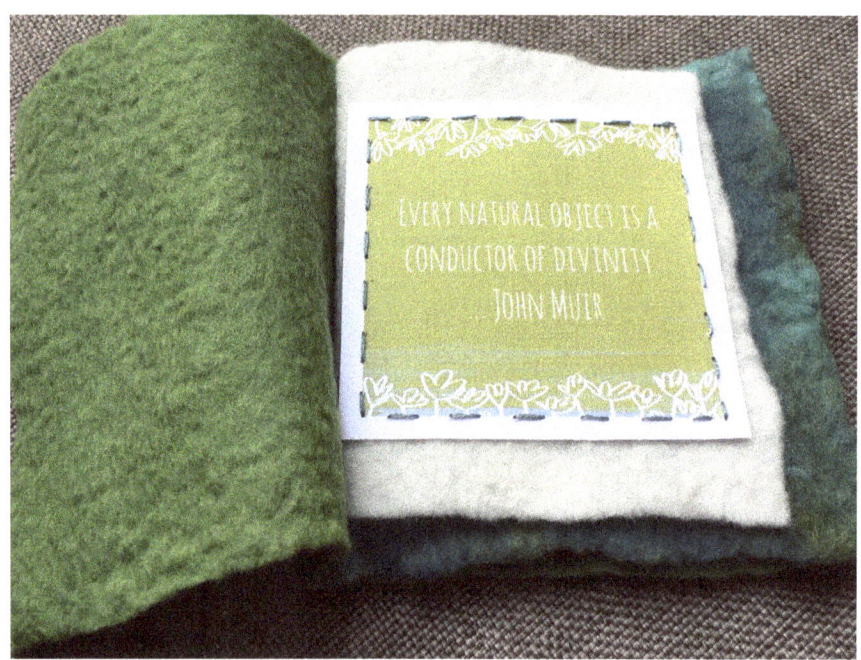

Last Word

I have always been more interested in what comes out of making art and the conversations that can happen when viewing art than the actual art itself. Because of that, I couldn't write a simple "how-to" book. I believe that for art to have impact, it needs to come from a place deeper inside ourselves. A beautiful landscape is lovely, but if it is only that, it seems limited. A landscape with an abandoned building in it suddenly has much more interest. Then there are questions that come to mind. Why was the building abandoned? Who lived there? How long ago? Then, just maybe, we start thinking about times we've felt abandoned. We might think about our ancestors and where they lived. Then the art turns personal and has meaning, at least in my estimation. I hope the "Take a moment" sections of this book caused you to think a little deeper about your projects.

I've attempted to introduce you to the wide range of techniques and uses for felt. This is a very cursory survey on the topic. I've also tried to show how art and, in this case, using the medium of fiber can be useful in working out feelings and emotions. I am in no way a mental health professional. I'm simply an artist who never thought she was until I reached my late 40s. I'm a person who experienced difficulties as a child and found making things, especially art, to be a wonderful tool as I walked a difficult path toward healing.

Lastly, take a look at my website, http://www.WalshFineFelt.com, for online workshops, in-person classes, kits, finished artwork, and more!

Happy Felting!

www.ingramcontent.com/pod-product-compliance
Lightning Source LLC
Chambersburg PA
CBHW041920180526
45172CB00013B/1342